PRIMITIVES
& FOLK ART

Cover Photograph
A fine example of folk art, described on page 51.

PRIMITIVES
& FOLK ART
our handmade heritage
BY CATHERINE THURO

Also by Catherine M. V. Thuro
OIL LAMPS
The Kerosene Era in North America

PRIMITIVES
& FOLK ART
our handmade heritage

ISBN 0 89145 112 9

Additional copies of this book may be ordered from:

Collector Books,	OR	Thorncliffe House Inc.
Box 3009,		4 William Morgan Dr., Thorncliffe Park,
Paducah, Kentucky 42001		Toronto, Ontario M4H 1E6

$17.95 ($19.95 in Canada)
Add 65¢ for Postage and Handling on first Book
and 30¢ for each additional Book.

Photography and Design by Catherine M. V. Thuro
Type set in Helios Light
Cover — Optima Medium

Published simultaneously in Canada by Thorncliffe House Inc.
Printed and bound in the United States of America

Published by

Collector Books
Box 3009
Paducah, Kentucky 42001

To Carl and Conover

Foreword

It has often been said that a tool is an extension of one's hand.

Most of us living in the second half of the 20th century are familiar with a maze of highly sophisticated tools — from the simple wrench which tightens the nuts on automobile wheels, to the tiny hand computer which has become so generally indispensable. Many of these very complex tools, some with interchangeable parts, have become an integral part of our lives; some have even become almost as important to us as food and clothing. Tools were not always this complicated and those who lived in the first half of the 19th century would find the technology which was developed over the next 175 years completely beyond their comprehension.

Life was comparatively simple in the time before the Industrial Revolution. Everything was made by hand, even the tools used in the manufacturing process. No two implements or tools were exactly the same, each one was unique because it was made by hand. Some were made by the hands of a superb craftsman or artisan, and others were crudely made by the hands of an unskilled person who devised the tool out of sheer necessity.

Handmade, or wrought tools have held my fascination for years. Each is different and, in some strange way, seems to give a glimpse of the individual from a former generation who was the maker. The tool is often the only legacy of immortality left by a frail mortal who lived many decades ago. My fascination is shared by those who collect and enjoy "our handmade heritage". We respect and admire ingenuity which makes man strive to improve his lot and then invent the methods of doing so. This fascination has a subtle way of catching up with one and then the handmade heritage becomes a passion and an obsession.

Those who have read Catherine Thuro's first book, "Oil Lamps—the Kerosene Era in North America" know of her dedication to accuracy and there is no one who can surpass her definitive knowledge of kerosene lamps. The book is a fine example of superb research combined with an ardent desire to produce a learned work on a most interesting subject. In terms of years, Catherine is a comparative neophyte to the cult of collecting artifacts that reflect our social history. However, like so many converts, she has become enthralled by her subject and has studied it with passion and fervor. "Primitives and Folk Art — Our Handmade Heritage" is a result of several thousand hours of work by this truly dedicated scholar, author and photographer. Her thorough knowledge of the subject is a result of her devotion to zealous research. It would take dozens of volumes to cover even a small part of our handmade heritage, so she has had to pick and choose those items which should be included in this book. She has done this with a discerning eye and an innate intuition of what will please and interest her readers.

I have had the privilege and pleasure of observing at close range the birth of this fine work, and I would like to pay tribute to her dedication. It is indeed a rare occurrence when someone writes a scholarly manuscript, combines this with their own very pleasing photographs, and then designs such a lovely book, which, I am sure, will be enjoyed by thousands.

Russell K. Cooper
Administrator Historical Sites Division
The Metropolitan Toronto and Region Conservation Authority
Black Creek Pioneer Village, Toronto, Canada

Preface

In the world of antiques there are many interpretations of the words primitive and folk art. Authors of books or catalogs who describe objects as primitives or folk art, generally provide their own interpretation so that the reader may understand the writer's approach. As a reader, it becomes discouraging to try to sort out, not only the opinions of various writers, but also the opinions of the critics who review their work. At times it seems these explanations begin to snowball, gathering up more and more abstract adjectives on the outside, and getting further away from the idea at the core.

To compile a book on primitives and folk art, the author must define the interpretation of these words in the book. Folk art and the word primitive when used as a noun are explained following this preface.

Primitive as an adjective is given such synonyms as old-fashioned, rudimentary, primeval, uncivilized, simple and austere. The translation from latin means simply, "first things". Many of the articles chosen for this

book may be considered first things used by settlers in the past two centuries, but they were selected primarily because of their apparent handmade quality. This quality was not only confined to articles made at home, but also to those small shop or factory products that reflected the human touch. Handmade quality has an appeal today for those who feel our quality controlled mass-production processes, have destroyed all evidence of any relationship between man and product.

Interest in early handmade artifacts is not merely in the contrast with today's precise mass-produced articles, but in the association of the articles with the people who made or used them. If our curiosity leads us to investigate the origin, date and use of an artifact, then the answers will probably make us more curious about all things relating to that particular period of time. Examples of our handmade heritage can be studied in several books including those mentioned in the bibliography. They can also be seen in restored homes and villages, in settings that have compatible articles of the same period. Museums that specialize in certain subjects such as folk art, tools, dolls or primitives, appeal particularly to those who have studied the subject. Opinions vary with regard to the display of antiques out of context. For purposes of study, there can be advantages to this approach.

I believe that by taking objects out of their traditional and chronological environment and highlighting them in a harmonious or compatible setting, curiosity and close examination are encouraged. Whenever these objects are encountered in the future there is a good chance that they will be instantly recalled. They will become part of the endless and ever-expanding truism:

> The more we see, the more we learn,
> The more we learn, the more we see,
> and enjoy!

Primitives & Folk Art

Folk art in its purest form applies only to the usually disciplined designs handed down through generations of people with common religious and/or ethnic origin. The broadest description of folk art includes everything with artistic merit created by and for people in general, as opposed to fine or academic art with a background that has an appeal primarily to the intellect. Unfortunately the use of various descriptive adjectives to define folk art categories leads to much confusion. Primitive art, naive art, pioneer art, vernacular art and traditional folk art usually are described as categories with characteristics that generally parallel the dictionary meaning. In some instances however, writers have chosen an interpretation completely opposite to the dictionary meaning or to those offered by other writers. If these adjectives are used alone, one cannot be sure if they are used to describe a characteristic or a category.

For these reasons it is quite in order to question the meaning of any descriptive terminology. I will offer a definition of the words folk art and primitive as I consider them to pertain to objects in this book.

Folk Art

Folk art alludes to objects having design elements such as line, form, texture and color combined in such a way as to produce an interesting or pleasing entity.

They may be:
1. Articles created for the sole purpose of decoration, eg: painting, sculpture, wall hangings, etc.
2. Functional articles with applied decoration.
3. Functional articles without applied decoration.

The quality of a particular piece of folk art is related to its artistic merit and originality, and should be judged on that basis regardless of whether or not it evolved from a specialized skill in a particular craft.

The degree of training or the originality involved in producing folk art is often debatable, and sometimes impossible to establish. Surprisingly, this is the basis relied upon by many who wish to distinguish between folk art and craft.

Primitives

The noun primitive has a certain connotation accepted by historians and anthropologists, however among dealers and collectors of Americana and Canadiana, it has become a generic term used to describe many products of the past two centuries. I have chosen to use the word primitive to describe an article that has interest or significance because of its association with the development of our social history. Most of the artifacts in this book have the characteristics I ascribe to folk art, or are examples of my definition of primitives.

Within these terms of reference one could learn to quickly identify folk art, and recognize primitives as articles without folk art characteristics. Handmade quality or the evidence of individual expression or influence, were prerequisite considerations in selecting most of the articles for this book.

It may be a useful exercise to observe many artifacts including those in this book, and classify them in order to develop a greater understanding of primitives and folk art.

Judgement of the quality of a particular piece of folk art, or deciding whether in fact it may be considered an example of folk art, is subject to individual interpretation. I believe that the ability to analyze the inherent design elements and judge artistic merit, is much more important than the choice of words used to describe them.

Acknowledgements

At this point in time, there is a thin thread of memory and experience that links us with the objects illustrated in this book. Those born around the turn of the century or before, and perhaps those living in areas less technically advanced than North America, may recall seeing many of these objects being used or made, or having made or used them personally. This thread will be broken a few years hence, so we should be taking advantage of its existence today.

Dealers, collectors and researchers have been responsible for recording information either directly by publishing their own material, or indirectly by making it available for others to publish.

There are many who have contributed to the selection of the primitives and folk art shown in this book, and to the information about them. Their support and friendship were part of the great pleasure I have had in the preparation of this book.

I would like to offer a special thanks to:

Lawrence and Mabel Cooke for sharing their hospitality and considerable fund of knowledge. Mr. Cooke, editor of the book "Lighting in America" contributed the Bee Lining story on page 28.

Russell K. Cooper, Administrator of Historical Sites of the Metropolitan Toronto and Region Conservation Authority, and of Black Creek Pioneer Village, who as my enthusiastic mentor taught me the importance of careful examination and deduction in my research, and who devoted many hours reviewing my photographs and manuscript.

Hyla Fox, well-known photographer and writer who is the weekly antiques columnist for the Toronto Star, and the Canadian correspondent for the Maine Antiques Digest. She is currently preparing a book on samplers, and has written about them on page 21.

My husband Carl, for his constant help and encouragement throughout this project. Many aspects of the book reflect his expertise, interests and guidance.

Our sons, Randy (who once again had a hand in my book, page 40), and Ken and Wes, who were encouraged to become self reliant during its preparation.

Peter and Leah Woloson who share my interests, and who were so helpful with both this and my last book.

In addition to the above, there were many others who gave freely of their time and knowledge and who allowed me to photograph their collections. My sincere appreciation and thanks are offered to:

Arthur and Mary Armstrong
Betty Atlas
Richard Axtell
David and Anita Bates
Peter and Marian Blundell
Ted and Nancy Brooks
Bill and Sandra Caskey
Donald Colling
Miner J. Cooper
Lois Creptyk
Stan and Clara Jean Davis
Bill and Peggy Dixon
John and Dorothy Dobson
Jean Drapeau
Elizabeth Emelio
Edward and Alice Farr
Dick and Jan Ferris
Gerard Funkenberg

Bill and Wendy Hamilton
Margaret Hesp
Don and Muriel Hiles
Doreen Howard
Jeanne Hughes
June Kennedy
Keith Leonard
Duncan Macaulay
Peter Matthews
Forbes and Katherine McGregor
Charles J. Mitchell
Lorraine O'Byrne
Earl Patte
Margaret Philip
Al and Maryan Russell
Linda M. Smith
David Stewart
John and Barbara Todd
M. B. Wessel
John N. Wright

The more we see, the more we learn,
The more we learn, the more we see,
and enjoy!

Contents

Art and Decoration

Articles chosen for this section are those
described in categories 1 and 2 on page 10,
namely, those created for the sole purpose of
decoration — or decorated functional ones.

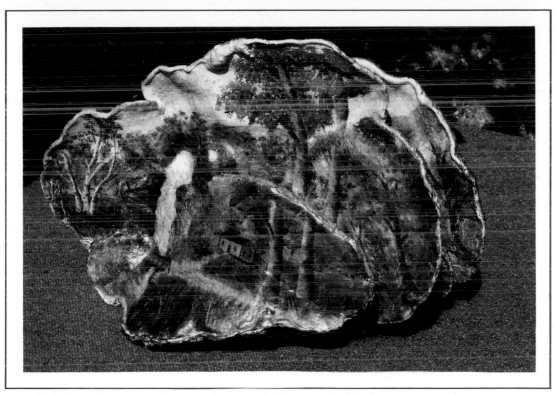

a. Painting pictures on fungus, plates and other small objects was a popular pastime in the late 19th and early 20th centuries. In this example, the artist has continued the design on successive layers, to quite literally increase the perspective. This piece is 17" wide.

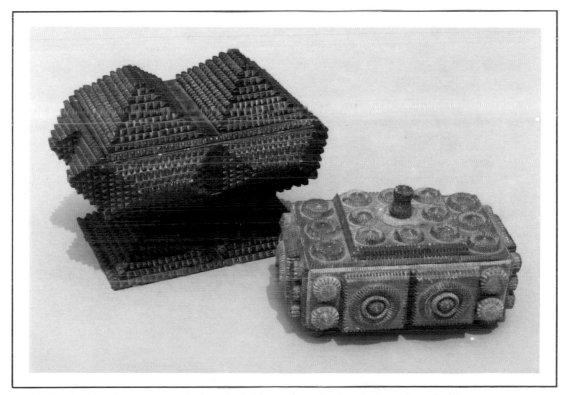

b. Used cigar boxes provided material for a favorite North American hobby or pastime. The wood from these boxes was laminated and chip carved, and the articles made are known as Tramp Art. Boxes are the most common form. Others include full scale and miniature furniture, clock cases, picture frames, and shelves. They were made in the late 19th and early 20th centuries, but individual pieces are difficult to date. The box on the left has a mirror under the lid and is 7" high, 10" wide and 7" deep. Right is 4½" high, 8½" wide and 6" deep.

a. Subject matter and style both contribute to the success of this delightful oil painting of two boys caught in the act of stealing apples. Probably last quarter 19th century. Unsigned, oil on canvas 14¾" x 21".

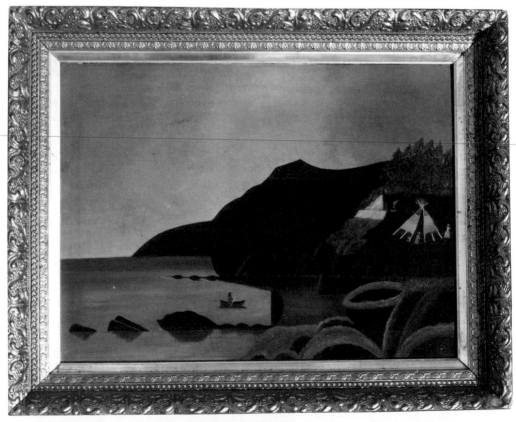

b. A small, well-executed and very realistic version of this painting was offered for sale a few years ago. It was also unsigned, however, the frame had Labrador written on it in two places. Research indicates the painting shown here was done before 1896. Oil on canvas, 18" x 24".

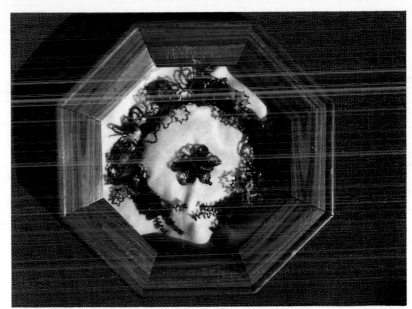

a. Hair wreath

(a) Wreaths were made of feathers, seeds, shells, wax flowers and hair in the last half of the 19th century. This one was made from hair belonging to members of one family, and according to tradition it may only be added to with hair from female family members of successive generations. Hair was also used in making jewelry.

Although the needle engraving on both of these powder horns is the same type that is used on scrimshaw articles, experts would not classify them as such. One reason for this is that they are not made from a product of the sea. Another reason is that some would consider the ships depicted were only incidental to the overall piece, and were not necessarily the work of a scrimshander. The baleen box on page 29 would be classed as scrimshaw.

(b) Well-executed engravings on this powder horn include an English crest and a map, that covers an area from New York City to Lake Ontario. Two rivers are shown, the North (Hudson) River, and the Mohawk, branching off at Albany. It also includes Lake George and Ft. Ticonderoga.
Named on the North River are Ft. Edward, Royal Block House, Ft. Saratoga and Ft. Stillwater. On the Mohawk are (some with phonetic spelling) Lake Onyda, Fort Stanlwlx, German Flatts, Skenakedy, Forts Henry and Hunter.

(c) The nails, pine end, original cord and plug on this horn are details that distinguish old powder horns from reproductions. The inscription reads JOHN RANDALL AGE 26 YEARS. There is also a sailing ship, birds, trees, and flags, including what appears to be a Union Jack, and a tropical two storey dwelling.
Both powder horns are similar to ones associated with the 1755-1763 French and Indian war.

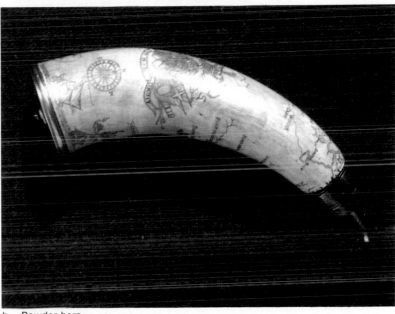

b. Powder horn

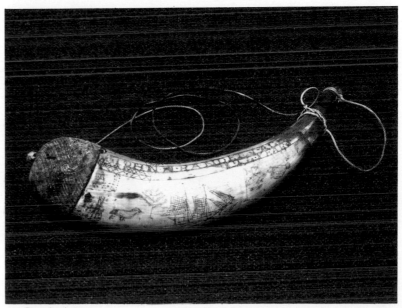

c. Powder horn

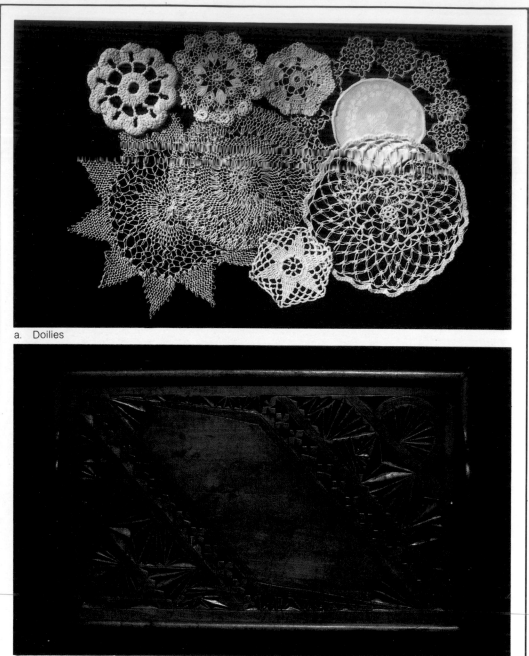

a. Doilies

b. Carved Tray

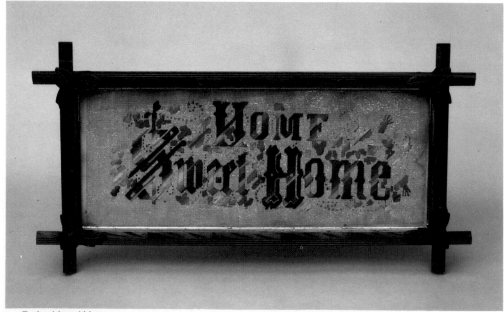

c. Embroidered Motto

(a) Doilies today may be the most common form of handwork that families can associate with their ancestors. They are often remembered as the work of a particular relative, and were stored away after their decorative or protective role passed. Auction sales for years have offered great quantities and varieties of these crocheted, tatted, knotted and embroidered pieces. With so many available it is an easy matter to collect an interesting variety.

(b) The deeply-carved surface of this tray suggests it was intended to be viewed rather than used, or at least used with care. The design is similar to those used in the late 19th century.

(c) Mottoes embroidered in bright colors on a punched cardboard background were popular in the late Victorian house. This Home Sweet Home was a favorite. Others expressed religious or secular sentiments such as; ''God Bless Our Home'', ''What Is Home Without a Father (or Mother)'', ''I am the Resurrection and the Life'', and ''Home is Where The Heart Is''

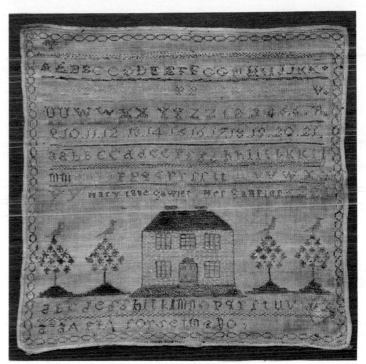

a. Sampler — Mary Jane Sawyer, C 1840, Nova Scotia, Wool on Linen, 17" square

Mary Jane Sawyer, her sampler

The unsophisticated, primitive work and features on Mary Jane's sampler become apparent after a few minutes of examination. Typical of some sampler makers, she avoided anything that might identify her age in order to protect herself from embarrassment in later years. Taking into consideration the materials used, the misformed and often misplaced letters plus the data discovered through genealogical research, it would be safe to assume that Mary Jane worked her sampler in the 1840's when she was approximately ten years old.

Samplers

Originally samplers were worked by adults, usually women, as places to record patterns, stitches and designs. However as the years progressed this initial purpose was forgotten, perhaps because of the advent of printed patterns, and samplers themselves changed from haphazard reference pieces to carefully-planned, well-executed and balanced work suitable for framing. Along with these significant changes, which took place mainly in the 18th century, the age of the sampler makers was lowered considerably.

To the small children who were forced to make them, samplers often became a dreaded experience, a real test of co-ordination, patience and skill. In many ways they were hurdles to overcome, in the same manner as losing that first tooth, learning to tie a bow, or even read. It was something that had to be done, like it or not.

Collectors have always found a certain appeal in these charming pieces of embroidery, either as a decorative accessory or as an unusual aspect of antique collecting. But, they are more than that. Samplers are among the few old pieces of our heritage that are often signed and dated, making them remarkable links to the past and vital tools in genealogical research. As well, they are often the only tangible proof that that person ever lived or even existed. Samplers therefore, are unique remembrances of the people who never quite made it to the history books.

It is possible and often times very easy to acquire a sampler, research the worker and learn about their children, families, ancestors and lives. Mary Jane

Sawyer's sampler is an excellent example. It was found in the mid-1970's at an Antiques and Folk Art Show in Bowmanville, Ontario. The vendor knew only that he had purchased it from a picker in Nova Scotia who had said that the Sawyer family was a very old one in that province. This one clue allowed some simple yet exciting genealogical research to be done, and is typical of the wealth of information and history that is available with a minimal amount of digging.

The history of this sampler-maker's family traces back to Timothy Barnaby who was born in Plymouth, Massachusets, in early 1706. He and his wife Martha, had at least one son, Timothy Barnaby, who moved to Lebanon, Connecticut and somehow managed to find his way to Cornwallis, Nova Scotia where he became one of the first land grantees.

Eventually Timothy Barnaby (whom we will call the second) married Elizabeth Beckwith — the daughter of John and Jean Beckwith — in Cornwallis in the year 1762. Of their eleven children Timothy (the third) was born January, 1777, and he married Jane Chipman, the 8th of September 1802. His wife Jane was born March 19th, 1785 to John and Eunice Chipman.

Jane and Timothy Barnaby (the third) had seven children, and one daughter, Olivia, married William J. Sawyer, the son of Sheriff J. J. and Eliza Tobin Sawyer of Halifax. Mary Jane, their daughter became the second wife of Wentworth Eaton Barnaby, possibly a cousin. They had eight children, four boys and four girls.

HYLA WULTS FOX

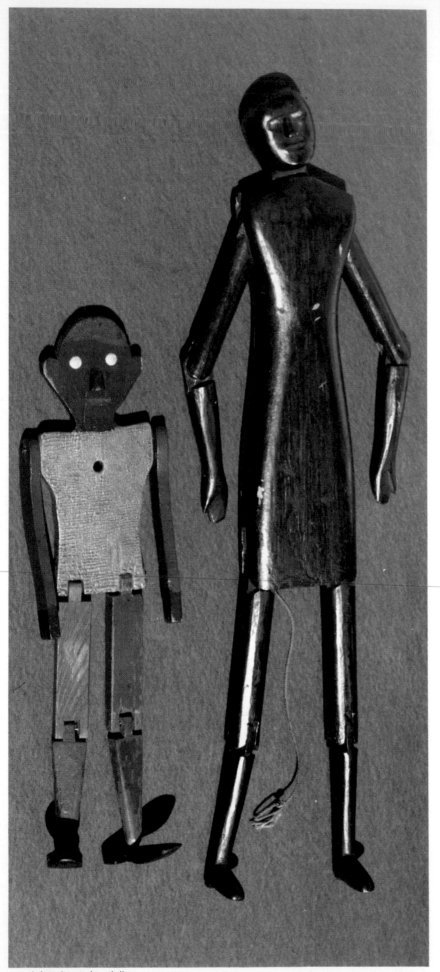

a. Jointed wooden dolls

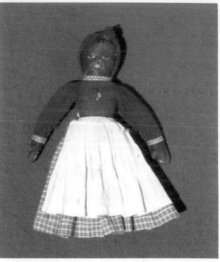

b. Reversible doll — black side

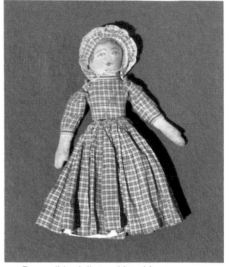

c. Reversible doll — white side

Black Americana and Canadiana includes articles with black subjects, and ones created by black people. Recent attention focussed on this subject has made it one of the fastest rising areas of interest among collectors.

(a) The 14½" jointed doll on the left would have been supported from the back by a flexible stick or piece of dowelling about 18" to 24" long. Many of these sticks were curved downward and fastened to a paddle-like board that served as a dancing platform. There were also factory-made ones, and at least one type was patented. They were popular during the last half of the 19th century. Jumping jacks had their limbs activated by pulling a string (see page 38). The tall 22" wooden doll on the right, is an exceptionally fine piece of 19th century folk art.

(b) and (c) Both aspects of a 14" reversible doll are shown here. This type of doll was probably made from a pattern that included the face. When the skirt is flipped over both color and costume are changed.

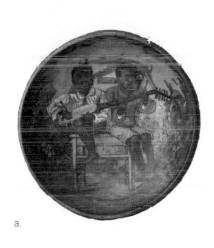

a.

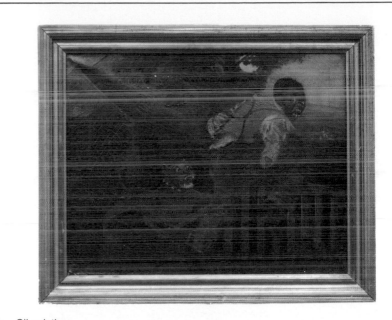

b. Oil painting

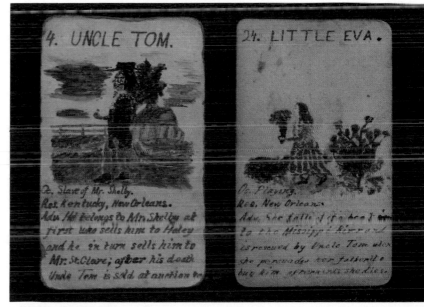

c. Uncle Tom cards

(a) and (b) Black subjects are painted in oil on a 9¾" diameter plate and on a 16" x 20" canvas. Although the subject in (b) is stealing, as in the painting on page 18, the ferocity expressed by the dog, and fear by the boy, attest to the more serious nature of the deed. Both pictures however, treat the boys' misdemeanors with humor.

(c) The Uncle Tom cards shown approximately full size here were made by Edmund Platt, January 11, 1862. Several of the 42 cards in the set are unfinished, and their purpose is obscure. They may have been part of a game, or perhaps teaching aids for either the story or the Uncle Tom plays that were popular during the 1860's.

(d) Whirligigs usually mounted on a building or a fence post, were activated by wind power. As this cast metal figure turns the grindstone, his body bends forward, and the cap hinged to his ears, slips over his forehead to his nose. The painting of the figure and facial expression, make this a delightful piece. The wood base is 18" wide.

Whirligigs are regarded as excellent folk art examples that involve creativity, engineering and craftsmanship.

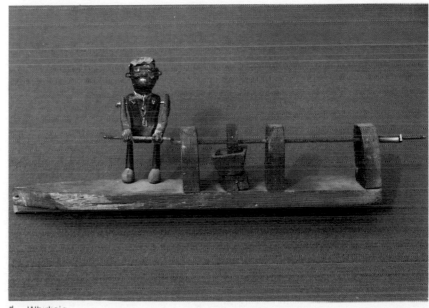

d. Whirligig

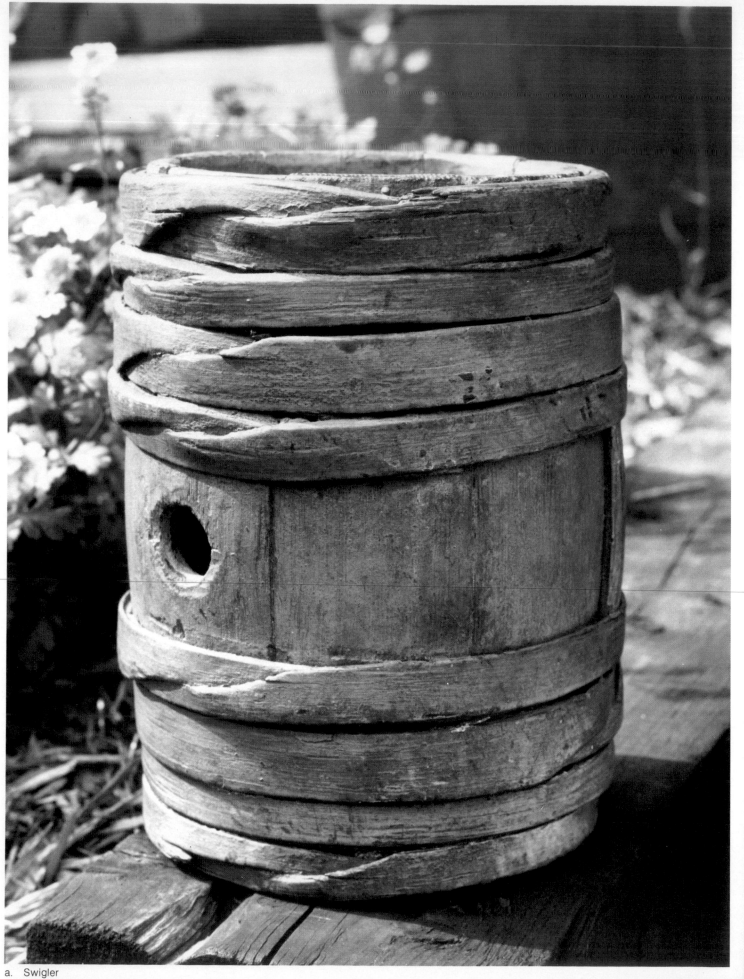

a. Swigler

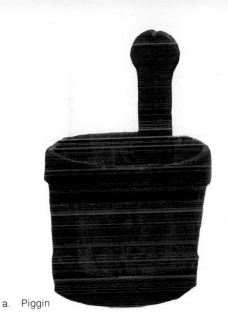

a. Piggin

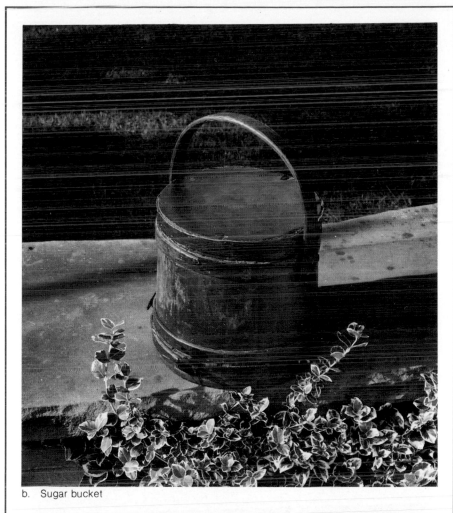

b. Sugar bucket

Barrels and buckets were products of the cooper's trade. Dry or wet coopers made barrels or casks for dry or liquid measures, and buckets with straight staves were made by the white cooper. The barrel is actually a liquid measure, and other sizes of casks were given different names. Barrels were also used as packing cases for shipping, and many factories had their own cooperage.

(a) Piggins have one stave extended to serve as a handle. A multi-purpose bucket, they were used to bail boats, for carrying feed or dry ingredients, and as a dipper.

(b) The construction of this sugar bucket in original color indicates it was factory made. It is 9" to the top of the lid.

(c) Sap buckets had a hole or wire loop that held them on a nail below a spile. These three average 12 inches in diameter at the top. Other sap buckets taper towards the top. Bucket staves have a tendency to shrink. When I set the lower right sap bucket on my knees to examine it closely, I was startled to find that in an instant I had a stave in each hand, two hoops around my knees, and was surrounded by eighteen pieces of wood!

◁ The small keg opposite is called a swigler, or in England a bever. It holds about two pints of liquid refreshment (rum, beer, water etc.) for factory workers, farm hands or perhaps students. Bever Time was the British factory workers' equivalent to our present-day coffee break. The American farm hand would take a "swig" from his swigler. Swiglers with small leather straps were sometimes clipped to a rum keg or rundlet which held about 18 gallons. Bevers usually had a longer shoulder strap or cord.

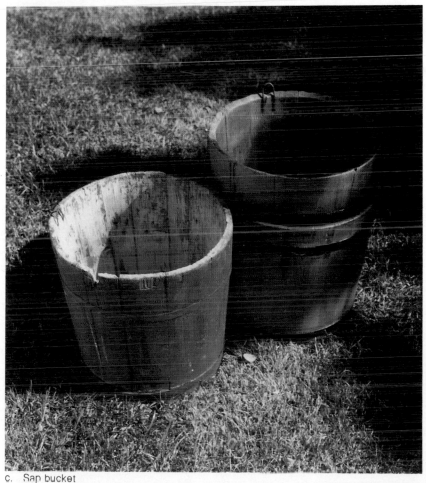

c. Sap bucket

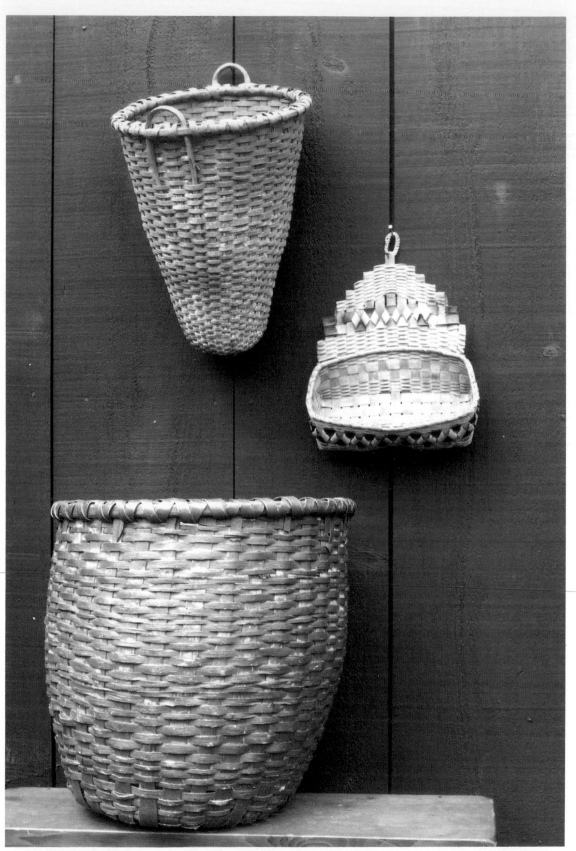

a. Cross hatch splint baskets

Baskets like so many containers, have specific uses ascribed to particular sizes and shapes, as well as a wide range for general use. Splint baskets made from thin strips of split wood are most common. Others were made with straw, bark, various weeds and grasses, and willow known as wicker. Most splint baskets were left unfinished, but some were painted, or decorated with simple designs. All splint baskets illustrated here are probably mid to late 19th century.

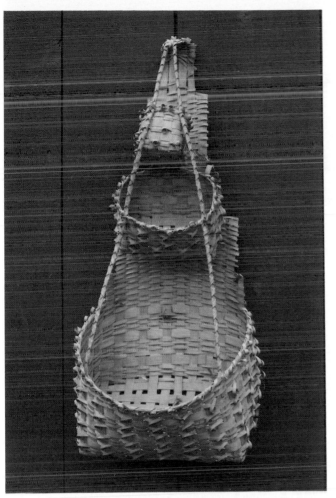

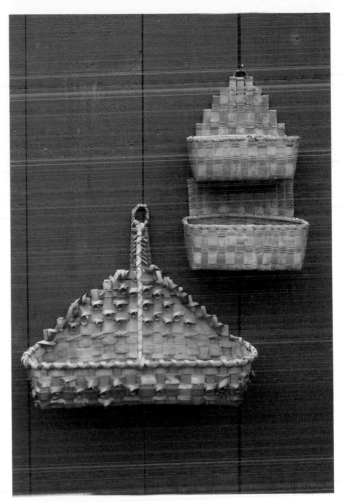

a. Splint wall baskets are usually referred to as loom or weaver's baskets. The triple one here is very unusual.

b. Left is a single wall basket with front brace, and above right is a double wall basket.

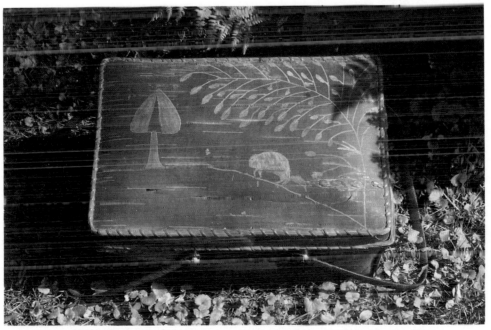

c. The beautifully stylized tree and branch, and the beaver drawn in a rather strange manner make this birchbark basket a delightful folk art piece.

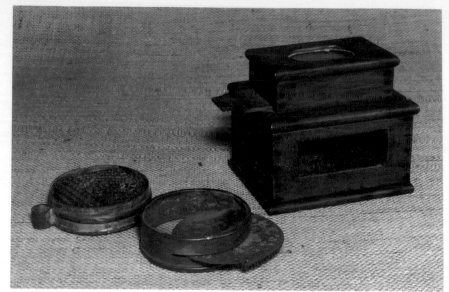

a. Bee hunting boxes

(a) Bee hunting boxes were made in a variety of shapes and sizes, in either wood or tin. The windows are usually glass, but sometimes mica. The two shown here have the honeycomb in the bottom, and a sliding partition to close it off. The tin box is 3" in diameter.

Bee Lining

The art of bee lining is best described in a small book THE BEE HUNTER by George Harold Edgell. "One's first task is to catch a bee. This is done by bringing the box up sharply under him with the lid open as he sits on . . . a bloom, and slapping the lid home as he tumbles into the box."

"Having caught the bee . . . darken the outer compartment, open the slide to admit him to the rear, and open the rear window. Seeing the light, the bee will promptly go in there seeking escape. Then . . . the rear compartment is closed, the front opened so as to catch another bee."

Provided with a dozen bees, a few are admitted to load up from a piece of honeycomb which has been filled with diluted honey or sugar syrup and released, a few at a time. By watching the bees against the sky, it is possible to determine the general direction of the wild honey tree.

The box is then left open and after a few round trips to the hive, we are ready to time a bee and see how long he is gone. In order to do this, it is necessary to identify an individual bee. From a piece of blue carpenter's chalk, scrape some dust and moisten with a few drops of water. With a tiny soft paint brush, dab the rear of a loading bee. "This must be done deftly and gently. Bees do not like to be painted." We now have an identifiable bee and can time him.

Allowing two minutes to unload in the hive, the balance of the time, divided by two, will give the distance based on a speed of about five minutes per mile.

At this point retrap a quantity of bees and after moving the estimated distance in the determined direction, repeat the above procedure. If the direction of the hive appears to be reversed, the tree has been passed, and if it is not readily found, triangulation can be performed by repeating the process from a point left or right of the bee line. Having located the bee tree, all that remains is to remove the honey!

LAWRENCE S. COOKE

b. Beehive

(b) This primitive beehive has handles that would enable one or two persons to carry it with arms outstretched, well away from the body. It is made from a hollowed out sycamore log, and would have had a lid or board placed on top, and a stick inside to support the honeycomb. Woven straw beehives, called skeps, were also used. The wooden box-type beehive came into use in the 1850's, and many variations were patented in the 1850's and '60's.

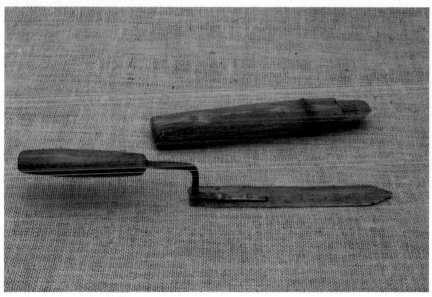

a. Honey uncapping knife

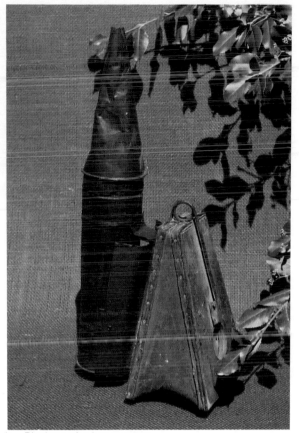

(a) Honey uncapping knives are used to shave off the top of the honeycomb, thus allowing the honey to drain out. This handmade one with a sheath is 16" long.

(b) Bee smokers have the effect of subduing the bees through fear. In 1877 it was written in The ABC of Bee Culture by A. I. Root in reference to calming bees, "It is here that the power of smoke comes in; and to one not conversant with its use, it seems astonishing to see them turn about and retreat in the most perfect dismay and fright, from the effects of a puff or two of smoke", and further "what would we bee keepers do with bees at times were no such power as smoke known?"

b. Bingham type bee smoker

Factory-made bee smokers such as this Bingham type, or the much more common Corbiel type, with the spout almost at right angles to the vertical cylinder, were used over a century ago.

(c) and (d) This homemade bee smoker still contains charred old rags. After igniting the rags, the plug is replaced and the bellows are pumped to keep the fuel smoldering, and to force the smoke out of the end of the tin tube. Rags, wood shavings or pine needles were used for fuel.

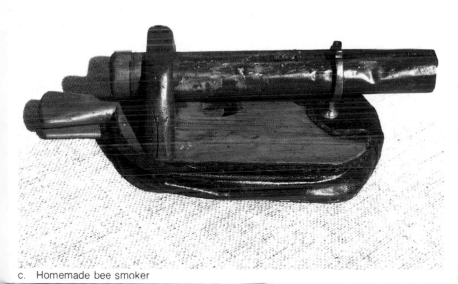

c. Homemade bee smoker

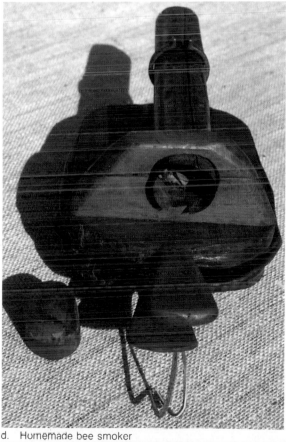

d. Homemade bee smoker

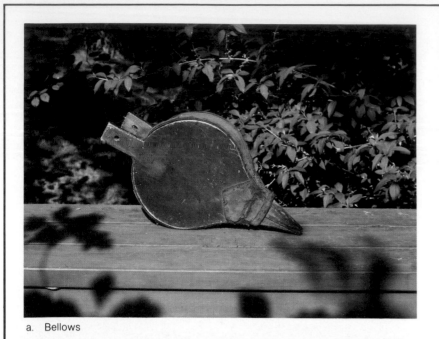

a. Bellows

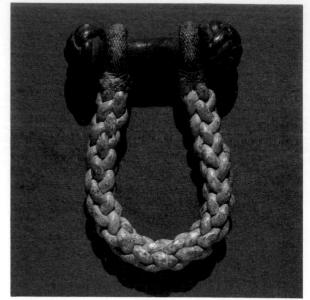

d. Beckett

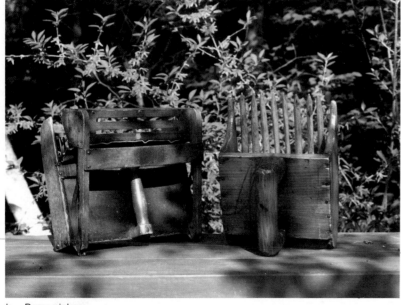

b. Berry pickers

c. Boot jacks

(a) Most bellows were used for "fanning the fire" in the fireplace or stove. This one however, was used in a print shop to blow dust and dirt out of the type cases. It is 19" long. Bellows several feet long were made for use by the blacksmith.

(b) Berry pickers used for cranberries, blueberries and perhaps other varieties were usually made of tin or wood like the scoop type on the right. The berry picker on the left will close with pressure on the bar that runs across the top.

(c) Boot jacks were made of wood, or of cast or wrought iron, like the very fine example on the left. The two crudely made wooden ones dated 1846 and 1885 are from a farm that was established in the early 1800's. They are 17" and 15" long respectively.

(d) A beckett is a handle for a sailor's chest. They were made in a variety of shapes and materials, some very decorative. This fine example is made of rope and leather.

According to Wallace Nutting, "The test of an antiquarian is that he knows the name of this and a few other things".

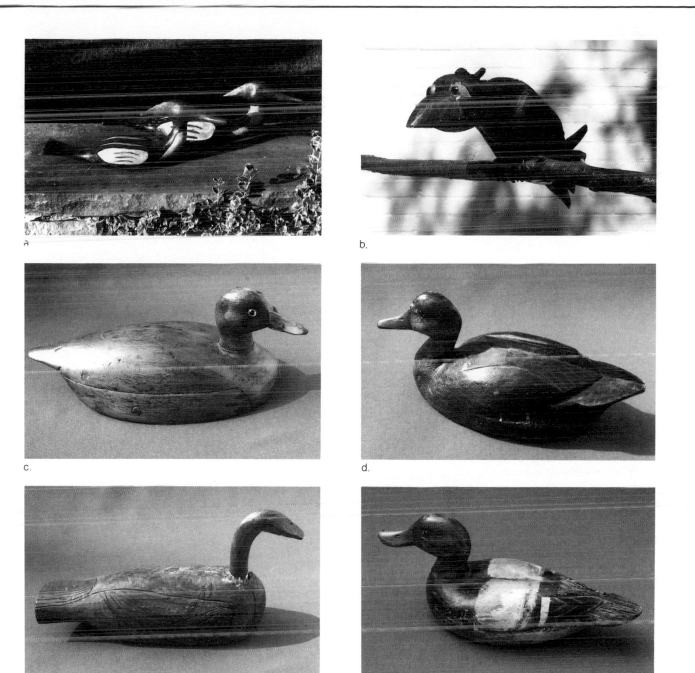

a.

b.

c.

d.

e.

f.

Birds abound in shops and at auctions. Those illustrated here were chosen by their owners for their overall appearance only. Serious collectors base their choices on rarity, condition, signature and other criteria. Shore-bird and duck decoys are still being made, and age does not seem to be as significant a factor among serious decoy collectors as it is in other areas.

(a) This exceptional pair of American mergansers is said to have been made in Nova Scotia. They are not weighted and measure 18" and 21½". The beautifully stylized form is quite contemporary.

(b) From Quebec, this crow or raven caricature is made of wood with leather comb and wings. It is securely mounted on the branch and balanced perfectly, provided the tail is allowed to remain below the level of the branch. This perhaps indicates it was intended to be mounted on a fence. It is 30" long.

(c) The very worn condition of this duck prompted the dealer to remove the paint. This revealed two carefully repaired areas that add interest to an otherwise plain 15" duck.

(d) Deeply-carved wings and tail make the sculptural quality of this 17" black duck its most important feature.

(e) A serpentine neck and unusual shape suggest this 14" duck is of Eskimo or Indian origin.

(f) A bar of forged iron has been used to weight this 15" duck. The head and tail feathers have been carved.

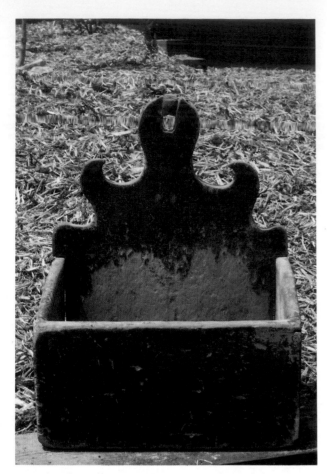

a. Rare early 18th century wall box with original paint that shows a considerable amount of wear.

b. An early 19th century double-wall box, with a striking diamond-shaped top.

c. All three pine boxes on this page are types that are often described as candle boxes, but could have many other uses. The sliding-top box with dovetailed corners is a very fine example of a rather common type. There is no evidence of wax inside. Mid-19th century, this box is 16½'' long, 7½'' high and 9'' wide.

A scrimshaw streetscape

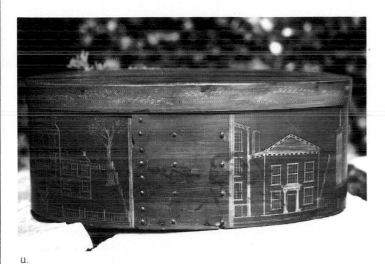

u.

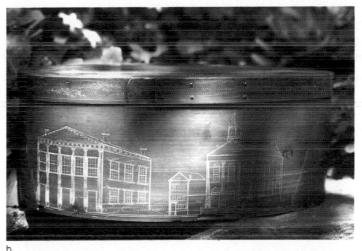

b.

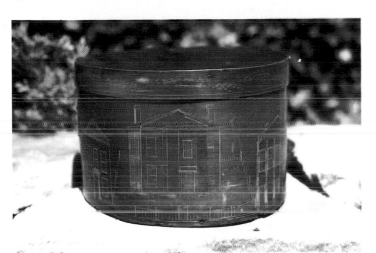

c.

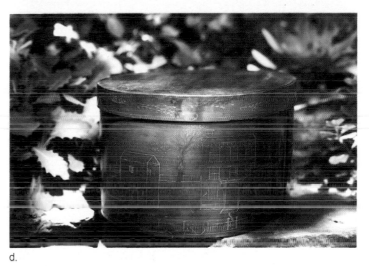

d.

The word scrimshaw describes the work of the scrimshander, and a scrimshander has been described as a person with a nautical association. Most authorities include under the heading scrimshaw, any object made from parts of a whale. In that regard the baleen box shown here can be considered an example of scrimshaw. Baleen whales as opposed to toothed whales, have attached to their upper jaws, horny plates with a fringe of bristles to strain out their food. These plates are known as whalebone or baleen.

Engraved designs on whalebone range from very crude to very high quality, but both primitive and precise pieces are prized by collectors. Some are inscribed with names, dates, locations or maps, while others have illustrations that assist in establishing their origin or date. In one instance a drawing of three pieces of Victorian glassware engraved on a whale's tooth, was obviously copied from an 1851 glass catalog. I came upon this surprising coincidence in "Scrimshaw and Scrimshanders" by Norman Flayderman, illustrating the whale's tooth, and "Antique Glass" by Geoffrey Wills, which reproduced the 1851 catalog illustration.

The streetscape on the baleen box depicts buildings that were possibly in a New England seaport. If this is so, the detailing of the strong architectural elements should make identification and dating relatively simple.

The box may have been a sailor's ditty box used to hold small personal items. It is also similar in size and shape to the band boxes that were very popular during the second quarter of the 19th century, and it may have been used for the same purpose. These were used by ladies for storage, or as a carrying case when travelling.

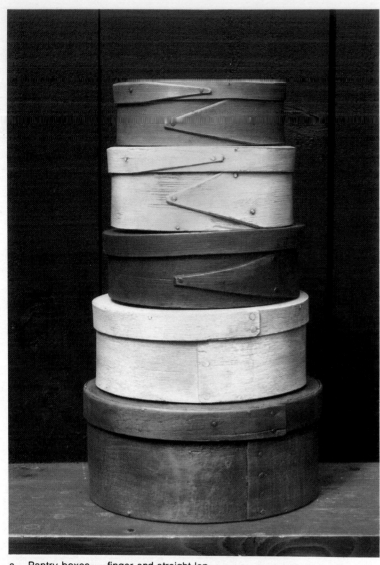

a. Pantry boxes — finger and straight lap

The boxes pictured here are referred to as pantry boxes, and were used to store dry ingredients. The way these wooden boxes were lapped and fastened, and the original colors retained, are the main characteristics that interest the serious collector.

Earth colors from clay used in making paint, or colors from natural sources such as plant juices, nuts or bark, not only blend beautifully, but also in the absence of printed labels, serve as color coding to identify the contents. Oval boxes made of maple with pine tops and bottoms held together without wooden pegs, and using copper nails are attributed to the Shakers. These also have long finger laps that allow swelling across the grain due to moisture, to be distributed over a larger area. This prevents the buckling that occurs with a straight lap.

There is a greater demand, due to their colors, for the boxes in fig. (b).

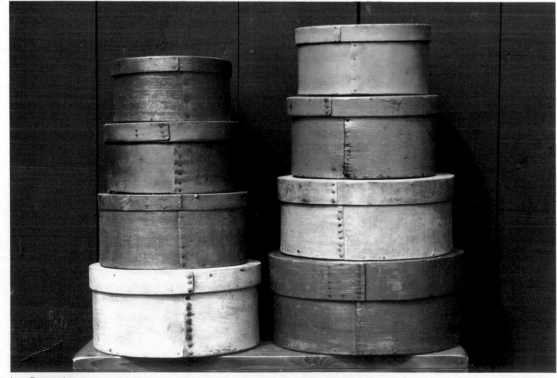

b. Pantry boxes — straight lap

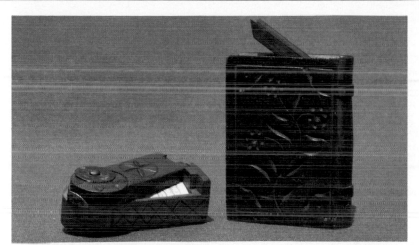

a. Secret lock box and spruce-gum box

(a) "K" is the key letter that unlocks this secret 4½" box on the left. When turned opposite a point in the hex design, the top may be pushed back and swung aside to reveal a compartment that is a perfect size for U.S. bills.

Lumbermen in New England and Canada made gum boxes as a pastime while they were in the lumber camps. This book shape was a popular form. They held spruce gum that was, and still is, used and sold as chewing gum or a tobacco substitute. Most of these boxes have sliding tops rather than the hinged top shown here. The usual finish is a varnish, and the carved decoration had either religious or secular motifs. The size of these boxes was fairly uniform. This one is 5" high, 4" wide and 1¼" thick.

Other uses have been ascribed to these boxes. It is said that they were used to hold snuff, and that the ones with sliding tops held prayer books.

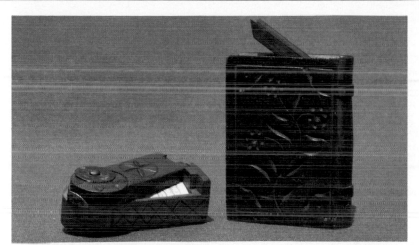

b. Salt box

(b) The brightly-painted salt box with the well-alligatored finish is probably 20th century. It is 8" high, 6" wide and 4½" deep.

(c) The use of balls, corn and beans, shells and stones, to cast a vote, has been practised for centuries. The word ballot comes from the Italian "ballotta" meaning a little ball for voting. In America during the last century, and even today in some secret societies and among other groups, black and white balls are dropped into a box to vote. White has always meant "yes" and black "no", hence the term "blackballed" for one defeated or rejected. Many of these boxes were made of tin, some with a funnel around the hole and some with handles. Others were made of wood with a varnished finish. This blue pine box with original paint and compartment to pass the balls around, is 8¼" long, 4" deep and 5¼" wide.

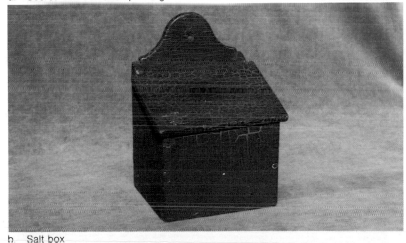

c. Ballot box

(d) Embossed and punched tin decorates this cigar box. Amethyst glass beads accent the design. It measures 9¼" long, 2½" high and 6½" wide.

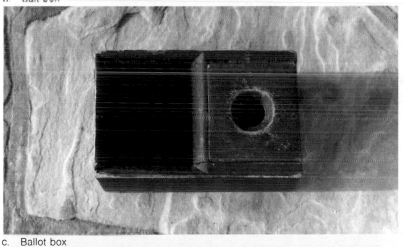

d. Decorated cigar box

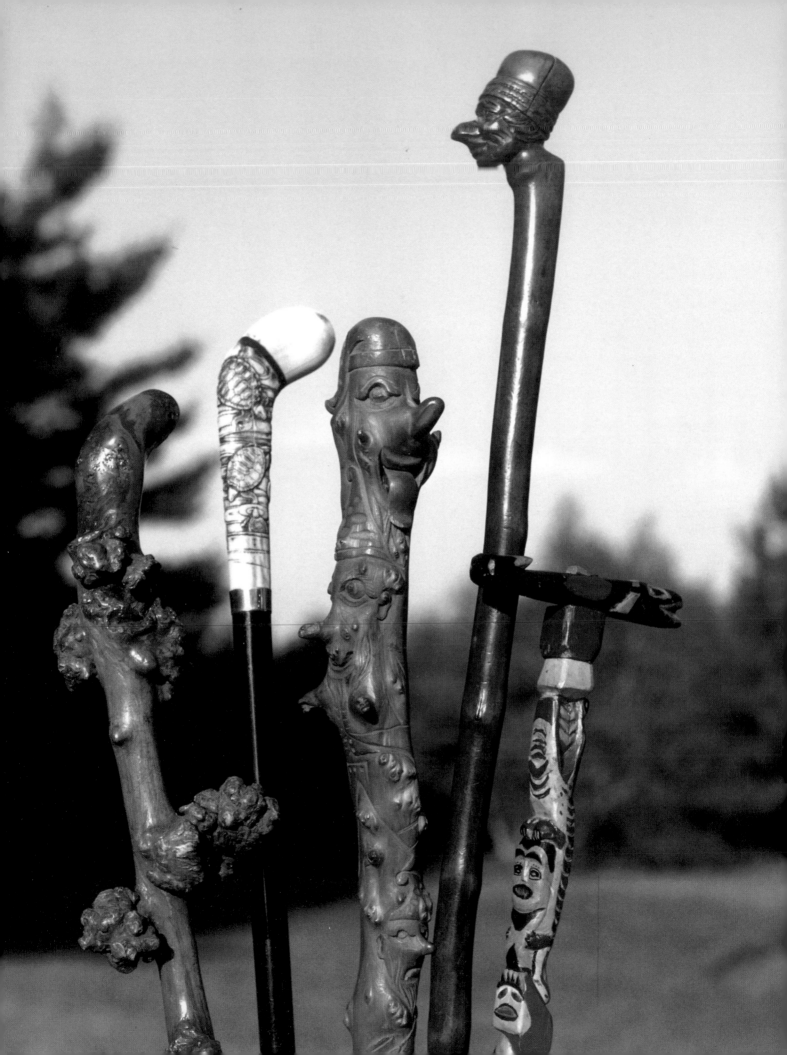

a. Ring toss game

◁ Opposite

The canes and walking sticks illustrated give an indication of the wide variety a collector has to choose from. Some prefer to collect a cross section of types, while others choose ones belonging to such categories as gun canes and other dual or triple-purpose canes, children's canes, scrimshaw canes and ones with birds, animals or human features.

CHILDREN'S PLAYTHINGS

(a) "In a small town around 1900, a grandfather made this ring toss game for his grandchildren. It would appear that grandmother also helped by covering the embroidery hoops with strips of cloth." This is the story that was related with the purchase of this game. The fact that an almost identical ring toss game was advertised in the 1914 Butler Brothers catalogue, casts suspicion on the accuracy of this information. In this instance, I believe Inaccuracies have innocently crept into word-of-mouth stories passed down through several generations; however, the practice of fabricating fanciful facts is not unknown. One should always keep this in mind.

Numbers beside the pegs give players their score. The pegs lift out and the crossed frame comes apart for convenient storage. This game is 20" x 20" x 17" high with 5" diameter rings.

(b) top. A baby's rattle was often made with interlocking pieces of wood, or with wooden rings around a center post. The chip carving makes this an exceptional example. 9¼" long.
(b) bottom. A faceted piece of glass that has turned amethyst, has been mounted in a wooden holder to make a delightful optical toy. The field of vision is reduced to each facet and gives a dazzling effect as it is moved about. It is 5¼" from the top to the bottom of the handle, and 3½" wide.

(c) Hobby horses, rocking horses and horses mounted on platforms with wheels were favorites with children. This laminated one with glass marble eyes, probably had wheels originally.

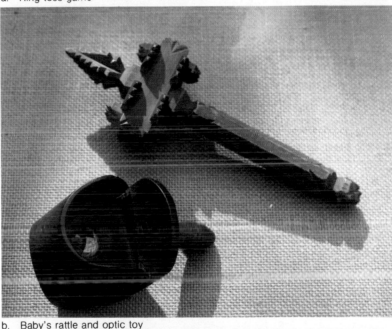

b. Baby's rattle and optic toy

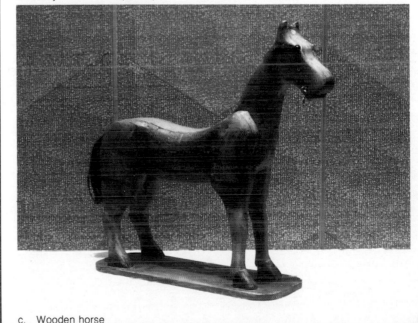

c. Wooden horse

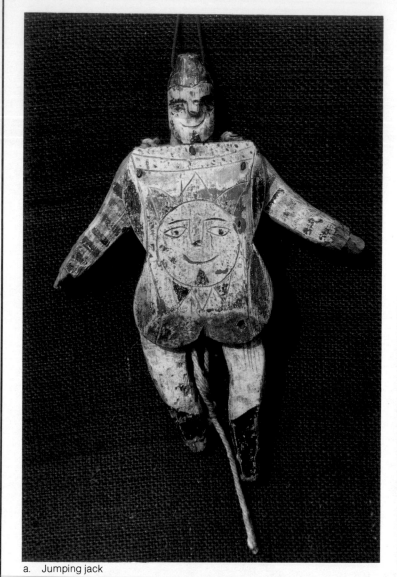

a. Jumping jack

(a) and (b) This jumping jack and one other like it are said to have been found in Canada. Two others have been illustrated in books, one described as having been made in England, and the other in Pennsylvania.

The size and the painted designs vary, but the shape of the body, limbs, head and facial details are the same. This suggests that at least the basic design was factory produced, and perhaps copies were homemade.

(c) The dolls and pieces of furniture emphasize the distinct difference between our plastic age and that which preceded it. The tiny wooden cutout doll is about 2'' tall.

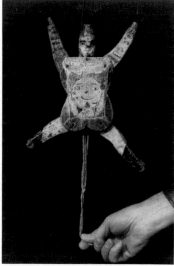

b. Jumping jack detail

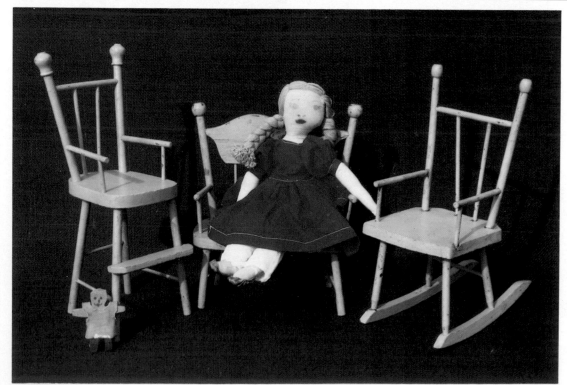

c. Dolls and furniture

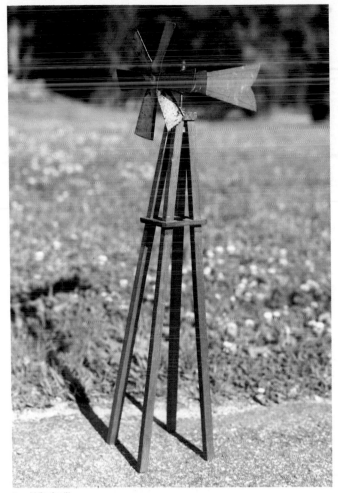

a. Windmill

(a) Toy wood and tin windmill — about 21'' tall.

(b) Miniature bookcase-chest with accessories. 11¾'' high x 9½'' wide.

(c) Miniature punched tole spoon rack with brass medallions, holding a miniature spoon and swizzle stick.

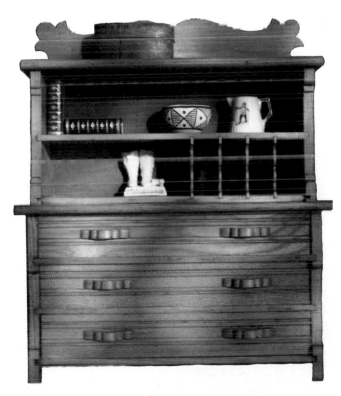

b. Miniature bookcase-chest

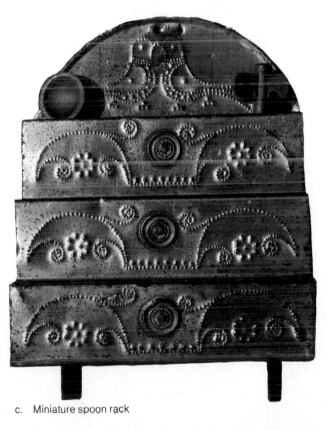

c. Miniature spoon rack

◁ The marble run opposite is a captivating toy that attracts and amuses all ages. The sound of the marble rolling down the wooden track, and the click as it hits the tin ends to reverse its direction, has a fascination akin to some of the so-called executive toys made today. There was also a double marble run game made with tracks that criss-crossed. Size is 24" wide x 21" high.

(a) Skittles is an old game that had many variations. String is wound around the peg of the top which is then held at the end of the game. A sharp pull of the string sends the top careening and caroming around the board and through the maze, knocking down the wooden pins. Numbers by these pins enable the players to keep score. The removable steeple is carved from one piece of wood, (with the exception of the spheres). Circular inlays in the steeple match those on the board, so it does seem to be an original part. This 19th century game from Quebec measures 42½" x 21½".

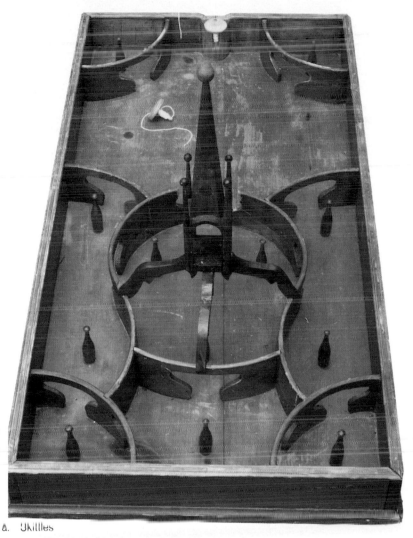

a. Skittles

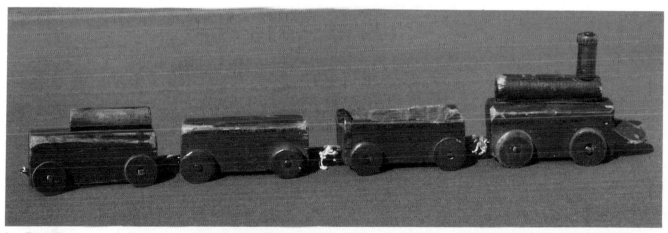

b. Toy train

(b) Much more imagination was called upon when toy trains looked like this. Handmade articles intended for children or sweethearts seem to have captured and retained an essence of the love that motivated their creation.
Found in a home in New York State, this 23" train with original paint is also 19th century.

a. Miniature flat-to-the-wall

(a) Miniature furniture was made for children, and as salesmen's samples. It is difficult at times to determine the original intention, but this piece does appear to have been made as a plaything. The original finish and gold decoration are in excellent condition. Size is 23¼'' high x 14¾'' wide.

(b) The more obvious the individual handmade character of a plaything, the more easily one can sense the love that went into its making. This doll's cradle from Quebec, is in the style of 18th century cradles. The paint is original, and the size 16'' long by 14½'' high.

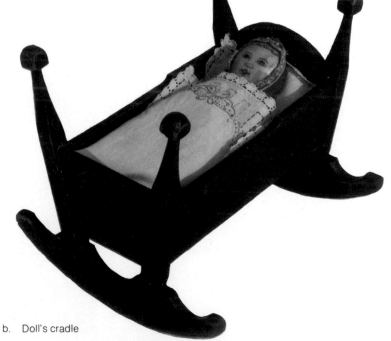

b. Doll's cradle

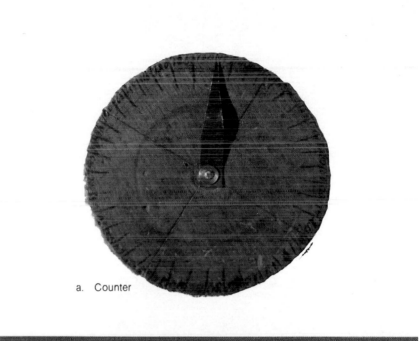

a. Counter

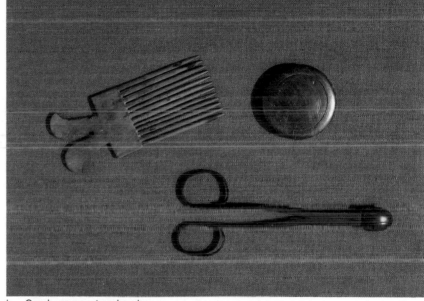

b. Comb, compact and curler

(a) Counters such as this were generally used to keep track of production units. The areas of wear on the face suggest the present tin hand is a replacement. About 6'' diameter, probably 19th century.

(b) Both functional and fashionable combs were made of wood. The one shown here would have been worn in the hair.
Also for milady, a lathe-turned wooden compact.
Cast iron tongs for spitcurls were sold in the 1930's. Decidedly earlier, these 19th century hand wrought tongs may have been used by a lady for her curls, or by a gentleman for his handle-bar moustache. 9'' long.

(c) Cigar molds are common and inexpensive. They have an interesting form, and make a good contribution to a collection of woodenware.

c. Cigar mold

a. Handmade calf weaner.

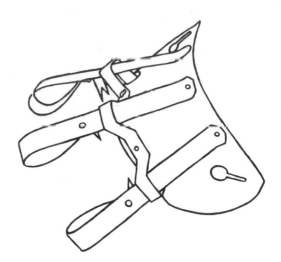

b. Patented, factory-made calf weaner.

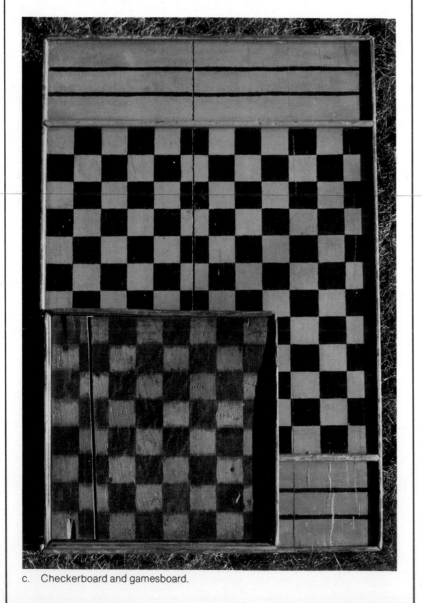

c. Checkerboard and gamesboard.

(a) There were two basic solutions to the problem of weaning a calf. One was to prompt the cow to give the calf a good swift kick each time it attempted to feed, and the other was to discourage the calf with devices designed to prod its nose or push a metal plate over its mouth. The well-constructed wooden muzzle, cushioned by the leather straps, was tied onto the calf's head. The forged spikes took care of the first method of weaning.

(b) Patented in 1886, the NU-WAY weaner was manufactured in Round Grove, Illinois. Sharp metal points jabbed the calf's nose, and provided a much more direct and certain deterrent.

(c) Checkerboards and gamesboards were made in a wide variety of sizes, designs and colors. The small board is crudely made, but the large, carefully-constructed one, is made with a spline and has reinforcements mortised into the back. It is signed N. S. Dagenais.

Slices of dried corn or walnut shells were often used as checkers. The large board measures 18¾" x 29".

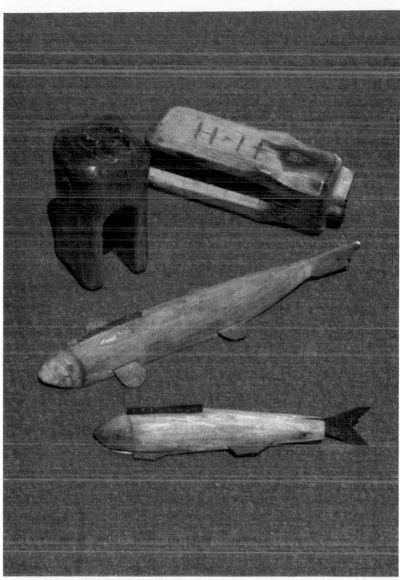

a. Fish-hook benders and fish decoys

The articles illustrated on this page are simple forms of objects that may be found in other versions with carving, color or material that would classify them as excellent examples of folk art or scrimshaw.

(a) Fish-hook benders were used to put back into shape, a hook that had been straightened by the strain of hauling in a "big one". Hooks were returned to their original shape by bending them around the hook outline. One of those illustrated has the outline made of wood with metal pins at the stress points, and the other has the hook shape outlined entirely with metal pins. These benders measure 3½" and 4½". Other types are reported to have been mounted on a finger ring.
The fish decoys are 5" and 7½" long, and are weighted with lead. Other metal parts have been made from tin cans, one of which has lettering that suggests it was made in Toronto, Canada.

(b) A fid is a spike used in sailmaking, or for separating rope in splicing, and therefore usually made of hardwood or whalebone. The one pictured with beautifully contrasting tones of heart and sap wood is made of lignum vitae, the extremely heavy, (will not float) hardwood from the quaiacum tree that grows in tropical America. Lignum vitae has to some extent become a generic term for wood with similar characteristics. This particularly large fid is 16½" long. They usually range between 5" and 15".

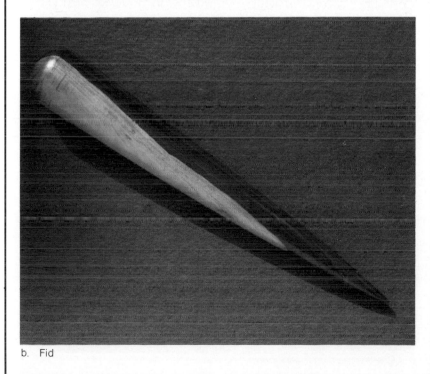

b. Fid

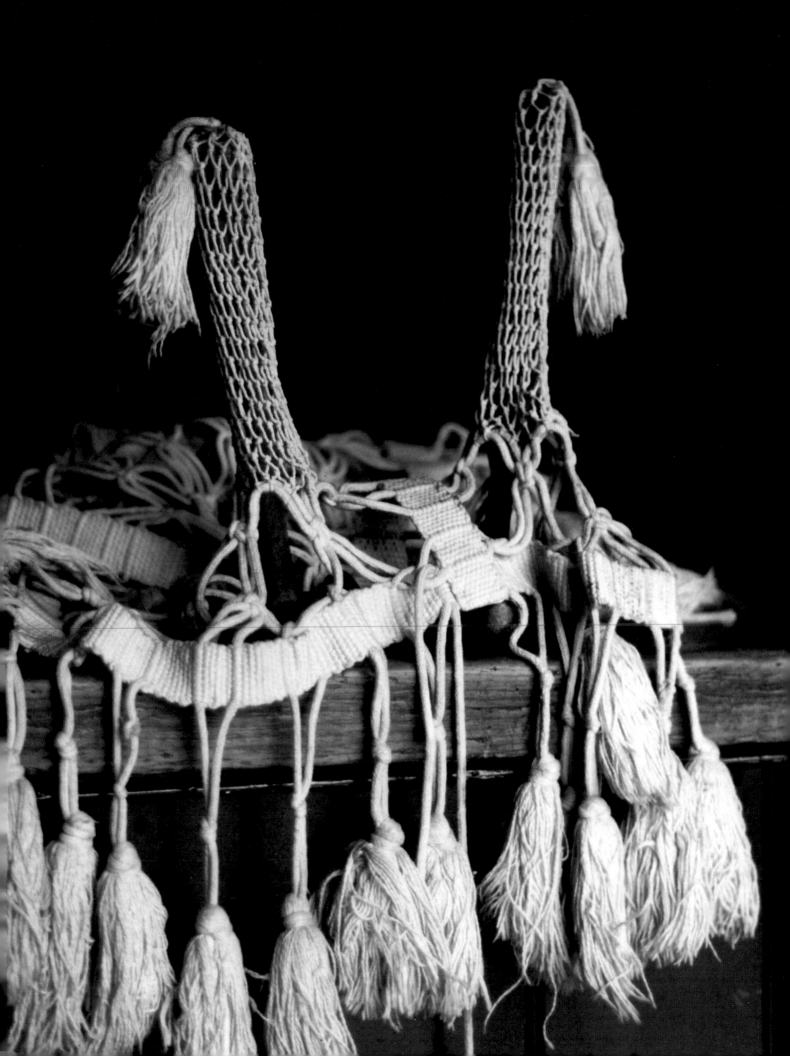

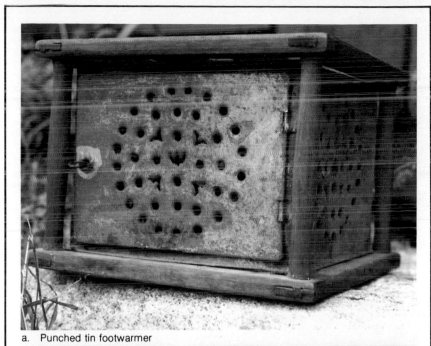

a. Punched tin footwarmer

◁ Fly nets that covered the head and body of a horse were made of cotton or leather. Some were plain, and others like the one shown opposite were fancy with tassels on the ear tips and lower edge.

Heat for footwarmers was provided by hot coals or stones, or by whale-oil or kerosene burners. Their most important use was to keep the feet warm while travelling in carriages.

(a) Footwarmers of this type were both home and factory made, and this one is probably the latter. A double one almost identical in design was also made. Hot coals were put into a separate tin box and placed inside the footwarmer. Very rare today are ones with the outer box made entirely of carved wood.

(b) Soapstone footwarmers could have been used in a carriage, or to warm a bed. This type with the wire handle is quite common today.

b. Soapstone footwarmer

(c) In the 1860's there was a rash of patents issued for footwarmers that were remarkably alike. The partly stencilled and partly freehand inscription in red paint on this one reads,

W. M. VANHORN'S
Patent Foot Warmer
Patented Nov. 24th, 1865
PITTSBURGH
FRONTENAC, C.W.

This was in the Kingston, Ontario area. The C.W. stands for Canada West, the name for this region before confederation in 1867. The footrest part is a double layer of tin, and would have originally been covered with carpet. The footwarmer served also as a lantern with whale oil providing the heat and light. A similar one patented in the U.S. at approximately the same time, used an identical brass handle.

c. Patented footwarmer

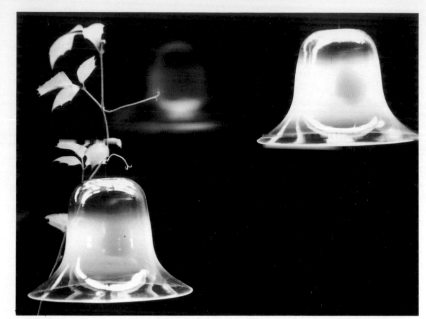

a. Opalescent electric light shades that have evident handmade characteristics.

b. An irridescent acid-etched shade with glass-beaded and gilt-edged butterflies.

c. Hollow vessels that required the skill of the glassblower. The cased glass lamp font has been cut, stained and painted.

Although it had been a factory operation for centuries, the manufacture of glass had until 1826, been the product of a skilled glassworker whose free-blown or mold-blown pieces reflected his skill, and perhaps his influence or expression. This was the date of the patent for a glass pressing machine that was to revolutionize the glass industry. With pressed glass pieces, the apparent relationship of worker to product disappeared, as a push of a hand lever was all that was required of him.

There was one problem that the pressing machine did not solve, and that was the problem of automatically making what is known as a hollow vessel. These are pieces of glass with a narrow neck or opening such as bottles or lamp fonts. The main body of a hollow vessel could be pressed, but the upper portion had to be reheated and drawn into the neck. The same molds could be used for vases and pitchers with the upper portion flared out or shaped. These manipulations constitute a handmade aspect of pressed glass. The great majority of hollow vessels however, continued to be made by glass blowers until an automatic glass blowing machine was brought into use about the turn of the century.

In addition to forming the basic shape, glassworkers and glass blowers created a dazzling variety of pieces that demanded extraordinary skills. Some of these pieces were created by skillful complex manipulations while forming the glass, and others had a surface treatment applied later. Occasionally pieces combined both.

Surface treatment could involve engraving, etching, cutting, painting and enamelling, staining and gilding. Understanding and recognizing the handmade qualities of glass will help one choose pieces of interest and compatibility with other handmade objects.

The pieces illustrated include hollow vessels that have been free blown or blown in a mold. There are also examples of pieces that have had a special surface treatment.

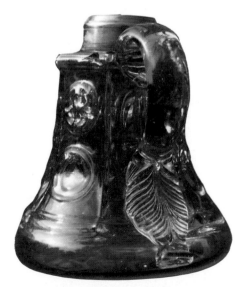

d. Close-up of the lamp shown in (c) reveals an exceptionally fine feathered trail on the handle.

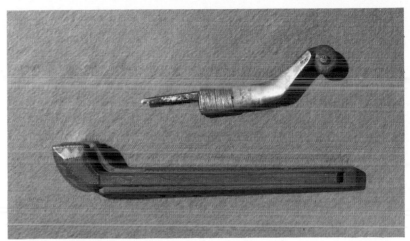

a. Knife and pipe box

Collecting articles made by North American Indians has been popular for many years. There is a tremendous range of decorative and functional items to choose from, and a small sampling is illustrated here.

(a) Crooked knives are relatively common, and exhibit a wide variety of shapes and decoration. The blades, said to be still available in some areas, could be replaced if broken.
The pipe case on the other hand, is very rare. Its 14" length establishes its age. During the 1780 to 1800 period the traditionally long clay pipes were reduced to this size. After this period they were further reduced.

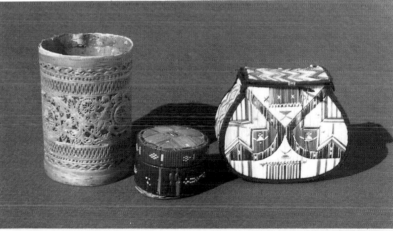

b. Birchbark and quill work

(b) A layer of metal foil has been sandwiched between two birchbark layers to make the container on the left. The lacy cut-out layer is joined at the back with tabs that are worked into the design. The inner core is seamless, and must have been taken from a log with a decayed core. This container is 6½" high, and was probably made by Eastern Woodlands Indians in the late 19th century.

Two examples of brightly dyed porcupine quill work are shown on the right. The small round box is attributed to the Micmac Indians about 1850 - 1870, and the purse-shaped one to the Penobscot Indians about 1870 - 1880.

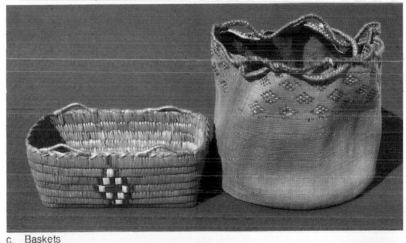

c. Baskets

(c) European influence is indicated in the loops on the 11" long basket with the imbricated pattern on the sides and ends. Finely-woven soft baskets that could be folded or pulled in with a drawstring, were made in the Aleutian Islands. The one on the right was made circa 1865.

(d) Beads and tin cones were obtained at the trading posts. The moccasins circa 1890 and the early 20th century choker are attributed to the Plains Indians. The Apache purse is late 19th century.

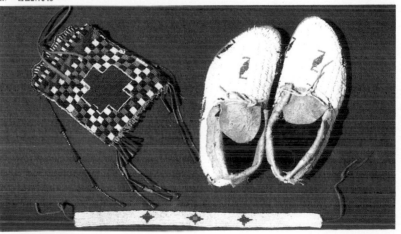

d. Beadwork

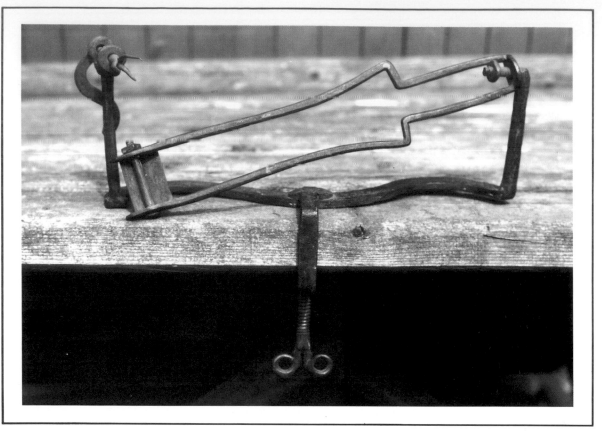

a. Most handmade apple parers pre-date the mass production of cast iron ones in the 1850's. The apple was held on the prongs of a fork, while a hand-held blade was used to pare it. All examples are rare, and this hand-forged type could be considered extremely rare. It is 12'' long.

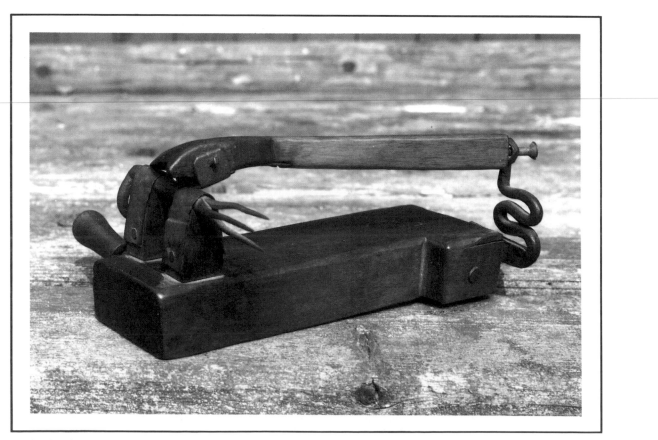

b. Apple paring bees were social functions in some areas. For this occasion it was the custom for a young man to try to design and make an improved model to be given to his sweetheart. This compact 6'' one could have been such a gift. The serpentine forged iron piece on the end is an interesting detail.

Complimentary
Value Guide to

PRIMITIVES
& FOLK ART
our handmade heritage

BY CATHERINE THURO

Whatever the motivation, investment, insurance appraisal, comparison or just curiosity, the monetary value of antiques at a given period of time is of interest to almost everyone concerned with the subject.

To compare one unique article with another, ranges between difficult and impossible, even if condition is similar. Local interest may affect prices, and an individual item may experience many increases as it moves about the country to areas of greater demand and / or affluence. It may also see several increases as it circulates at a single antiques show.

An expected price range is given here along with additional notes regarding many articles. Prices that vary considerably from this range should be questioned, perhaps mentally if they are much lower. In many categories the price of an exceptional example may be several times the cost of a good one. Articles made from figured, rare or unusual woods may cost several times more than a common wood. Original paint may also account for dramatic price increases. An excellent primitive or piece of folk art may cost thousands of dollars, or under a hundred. In some areas of collecting such as toys and decoys, where the prices range from about $20.00 to several thousand, interesting and acceptable examples can be found at the lower end of the scale.

Price ranges without notations apply to articles similar in quality and condition to those illustrated. In some instances slightly less or greater quality can affect the value considerably. Prices quoted are in U.S. dollars and are for the upper part of the Atlantic Seaboard, inland to Ohio, and for Eastern Canada. For some objects, increases of up to 50% may be encountered as one moves away from these areas.

If a single price is given, it is the price at which the example shown has been offered for sale or sold for in 1979, and is in keeping with the price of similar articles.

The special artifact that turns you on is the one that you should have if you can afford it. The satisfaction and delight it brings will far outweigh monetary good luck.

db

COLLECTOR BOOKS Box 3009 Paducah, Kentucky 42001

17a Painting on fungus. Usually in the $50-$125 range
depending upon size and quality. This one would be close
to the top of the scale.
 b Tramp art boxes are usually 35-75.
These examples would be mid-range.

18a Oil painting, boys stealing apples, 700-1000.
Values for many folk art paintings have seen
astounding increases recently.
 b Oil painting — 250 up

19a Hair wreath — 85-95
 b Powder horn 2200-2800. Map horns are rare, and
the quality of this one is exceptional.
 c Powder horn — 400-600

20a Doilies — .50-5
 b Tray, similar quality — 90-110
 c Motto — 25-50

21a Samplers (like the example shown), usually range between
150 and 300. Exceptional ones are much higher.

22a Left wooden doll. This quality would be 175-225.
Right tall black doll — 1000 up
 b Reversible doll — 250-275

23a Plate with oil painting — 250-300
 b Oil painting, boy stealing chicken. Unrestored — 800-1000
 c Uncle Tom cards — 550-650 for the set.
 d Whirligig — 400-500. Others are priced
from about 200 to several thousand.

24a Swigler — 100-150

25a Piggin — 35-75
 b Sugar buckets. Refinished ones start about 50 and those
with original paint about 90. The one shown
would be — 75-90
 c Sap buckets — 20-40

26a More common baskets may be found under 50, and
unusual examples under 125. Collector's favorites are
often expensive. Cross hatch splint baskets top — 80-95,
middle — 40-50, Bottom — 60-70

27a Splint wall basket - triple — 350
 b Top, double wall basket 250;
bottom, single wall basket 175
 c Birchbark basket — 150-175 (without split).

28a Bee hunting box, tin — 50-75; wood — 85-110
 b Beehive — 500

29a Honey uncapping knife — 35-50
 b Bingham type bee smoker — 20-40
 c Homemade bee smoker — 35-45

30a Bellows: common ones — 30-50
 b Berry pickers, left — 55-70; right — 85-115
 c Boot jacks, left — 70-85; center and right — 45-60.
Crude undated ones start about — 20
 d Beckett; Single — 75-95; more than double for a pair.

31a Pair of American merganser decoys — 300-350. Other
duck, goose and shore bird decoy prices start about 20
and soar to well over 10,000 for exceptional rare ones.
 b Crow or raven — 1500-2000
 c Decoy, stripped — 35-50
 d Decoy, black duck — 75-100
 e Decoy — 145-170
 f Decoy — 75-100

32a Wall box — 800
 b Double wall box — 375
 c Sliding top box — 125-150. Others range from 25 to
several hundred depending upon size, quality and condition.

33 Baleen box — 1800-2000

34a Pantry boxes — 32-42
 b Pantry boxes — 28-50

35a Left, secret lock box — 85-100.
Right, spruce-gum box — 45-60.
Many interesting examples are priced below 100
 b Salt box — 20-25
 c Ballot box — 125-150. Others start about 35

 d Decorated cigar box — 20-30

36 Canes and walking sticks similar in quality
and originality range between — 90-200

37a Ring toss game — 35-50
 b Rattle — 85-100. Optic toy — 100-125
 c Wooden horse — 600

38a Jumping jack — 300-350
 c Miniature furniture: Set — 45-60
Rag doll — 15-25. Wooden doll — 3-5

39a Windmill — 60-75
 b Miniature bookcase-chest — 150
 c Miniature spoon rack with spoon
and swizzle stick — 850-1000

40 Marble run: Single run — 40-60.
Double run games — 80-125

41a Skittles — 150-200
 b Toy train — 75-100

42a Miniature flat-to-the-wall — 185-225
 b Doll's cradle — 185-225. Doll — 350-400

43a Counter — 55-70
 b Wooden comb — 90-115. Compact — 20-30.
Iron curler — 35-50
 c Cigar mold — 20-40

44a Handmade calf weaner — 30-40
 b Patented calf weaner — 10-20
 c Checkerboard — 18-25. Gamesboard — 60-80.
Exceptional and/or decorated ones are over 100

45a Fish hook benders — 20-35, and some decorated ones
are over — 100. Fish decoys — 15-25;
these are also more expensive if exceptional.
 b Fid — 40-50

46 Fly netting — 20 up

47a Punched tin footwarmer — 100-135.
Unusual ones may be several hundred dollars.
 b Soapstone footwarmer — 15-25
 c Patented footwarmer — 150-200

48a Opalescent electric light shades — 50-75 a pair.
 b Decorated light shade with butterflies — 65-75.
Other shades start at about — 20, and go
beyond one hundred for Art Nouveau types.
 c Glass, hollow vessels, left to right.
1. Large bottle — 25-40
2. Round bottom bottle — 10-15
3. Syrup jug, strawberry pattern — 60-75
4. Star and Punty lamp with burning-fluid burner — 125-150
5. Kerosene lamp with chimney and burner — 550-650

49a Indian knife — 60-75. Generally — 30-100,
with extraordinary ones in the — 250-350 range.
Indian pipe box — 3000-4000
 b Openwork birchbark container — 350-450. Round quill
box — 85-110. Purse-shaped quill box — 200-225
 c Rectangular basket — 85-100;
soft basket unrestored with splits — 300-500
 d Beadwork purse — 225. Moccasins — 290-320.
Choker — 50-60

50a Hand-forged apple parer — 300-350
 b Wooden and hand-forged apple parer — 150-200

51a Wooden apple parer, left — 225-275;
right — 225-275
 b Wooden apple parer with gear — 175-200.
Knee type — 175-225. Hand-held blades
bought separately — 40-75

52a Apple parer, quarterer and corer — 250-300
 b Apple quarterer and corer. Prices for unusual
handmade apple processors start about — 75
 c Wooden goblet — 25-40. Bowl — 50-60

53a Breadboards, left — 120-140; upper right — 25-40;
lower right — 60-75. Butter dish — 30-45.
Bread fork — 25-35. Bread knife — 15-20

b Splintered birch brushes — 3 for 125
c Iron broiler — 210

54a Butter and chopping bowls, red — 175-225;
 green — 150-200.
 Butter worker scoop in burl — 110-140;
 in plain wood — 40-55. Angled handle worker — 35-45.
 b Butter prints, left — 105-120, center — 300-350;
 butter mold — 75-90; Scotch hands, pair — 25-35
 c Butter scale — 125-150

55a Cheese knife — 20-30
 b Cheese baskets, top — 175-225; bottom — 250-300
 c Choppers start about — 20; unusual handmade
 designs — 45-75. The one shown — 65-75

56a Churn — 100-125
 b Coffee Mill — 150-175
 c Coffee Mill — 150-175

57a Corn husking peg — 6-10. Many interesting
 ones are to be found under ten dollars.
 b Egg candler — 60-80
 c Dish drainer — 40-55. Unusual handmade
 ones have been priced — 200-300

58 Fireplace ovens, top — 135; center — 55,
 lower left — 75; lower right — 65.
 Hearth brooms — 125 each.

59a Hourglass — 650 up

60 Nesting graters, 2 pcs. — 150-175. Single grater — 70-90

61a Knife box — 75-100. Knife board — 35-45.
 Bath brick bought separately — 10-15
 b Cast iron tea kettle with tilter — 250-275.
 Kettle on right — 65
 c Kettle tilter — 235

62a Maple sugar molds, heart — 55-65; house — 175-200
 b Mortar and pestle — 125-150.
 Lathe turned ones start about — 60
 c Cabbage slicer without box — 75-100. Complete and
 exceptional ones up to — 500 have been offered.

63a Noggins, large — 150-160; small — 125-135.
 Funnel — 80-90. Potato masher — 25-30

64a Pastry print — 65-75.
 b Pastry prints, upper right — 45-55; middle left — 150-175;
 middle right — 85-100; bottom — 140-165
 c Pie prick — 50
 d Pie lifter — 30-40

65 Pot lid — 650-850

66a Porringer, burl — 300. Swizzle stick — 45. Reamer — 35
 b Swizzle sticks, top — 60-75; bottom — 80-95
 c Rolling pins, top — 8-12; middle — 15-25; bottom — 10-15
 d Iron skimmer — 40-55

67a and b, Spoon racks. Many imported old ones are offered
 from about — 60 up. North American ones start
 over — 100, and those like b start at — 3000

68a Spoon with rooster — 300-325
 b Iron kitchen utensils — 25-35
 c Iron kitchen utensils, left to right — 295, 295,
 185, 225 and bottom — 65-85
 d Brass and iron kitchen utensils, left — 185,
 other three — 500-600 for set.
 e Small horsehair sieve — 35-50

69 Large plaid horsehair sieve — 80-100

70a Wooden scoops, left — 85, right — 80
 b Spice cabinet — 85-100
 c Wooden sink — 175-200

71a Sugar auger — 100 up
 b Sugar cutter — 200-225
 c Sugar nippers — 250-300

72a Trammel, ratchet type. Many available at — 40-60,
 unusual ones are more expensive.

b Toasters, left — 255, center — 125, right — 125
c Trivet — 125 up

73 Kettle — 135; unmarked ones — 45 up. Fry pan — 135,
 Peel — 85. Chain trammel lower left — 65,
 hanging right — 50

74 Lye log — 75-100

75a Soap dish — 40-50
 b Soft soap scoop — 75
 c Lye stone — 150-175
 d Iron cauldron — 50 up; with size
 and condition being important factors.

76a Wooden washboard, early dated — 75 up
 b Wooden washboard — 25-35

77 Glazed pottery washboard — 85-125

78a Goffering iron — 50 up. Trivet, dated brass — 150-175;
 Iron — 160-185. Sad iron — 8-12
 b Wooden fluter — 75-90
 c Clothes pins — 4-8 and pulley — 20-25

79 Wash dolly — 30-40. Smoothing board — 90-120; prices
 vary considerably according to shape of handle and
 decoration. Wash tongs — 45-55

80a Spill plane — 200-250
 b Tinder box — 225

81 Splint holder — 300-350

82a Rush holder — 225-250
 b Basket cresset — 60-75. Most available are foreign made.

83a Double crusie — 75-100. Many are imported.
 b Betty lamp — 150-175, for this fine quality.

84a Baker's candle holder — 495. Spike candlestick — 85
 b Candle trammel — 1500
 c Candlestick — 75-100
 d Candle sconce — 325-390
 e Adjustable candlestick — 175-200
 Spiral candlestick — 200-300 is the average range
 f Candle box — 125

85 Wooden candlestand — 1500

86 Wooden candle lanterns (often foreign) and pierced tin
 lanterns, average range is 150-225. Examine the latter
 closely because reproductions have been made for many
 years.

87 Horn lantern — 185-225

88a Make-do lamp — 80-100
 b Beaded match holder — 12-18
 c Birdseye maple match holder — 110

89a Liquid prism — 175-200
 b Lard press — 40-50

90a Metal filligree — 20-30
 b Snowbird — 25

91 Windmill part — 60-75

92a Sheet metal horse — 300-350
 b Cresset — 60-75 (see 82b). Lion — 400-500
 c Wheelbarrow wheel — 20-30; pulley — 8-12
 d Ensilage fork — 20-30

93a Mousetrap — 20-30
 b Mousetrap — 60-75
 c Banjo — 45-60; flute — 45-60

94a Press container — 35-45
 b Cheese press — 90-100
 c Pack saddle — 100-125. Prod — 30-40. Poke — 20-30
 d Pipe kiln — 375

95 Pipe box — 2200 up; others start about — 600
 Pipe tongs — 1800-2200. Others of lesser
 quality start about — 550

96a Pitcher — 100-125. Funnel — 35-50
 b Insulator — 10-15

97a Pottery bowls start at about 25 and many good
 and useful ones are priced below — 100.
 b Undecorated redware and stoneware jugs, crocks and
 pitchers start about — 30. Those with simple decorations
 are priced from about — 75. Between 100 and 200 there
 are many attractively decorated and perhaps signed
 examples available. Exceptional ones and collectors
 favorites are much more costly. The ones illustrated would
 be from left to right — 90-110. Small jug — 30-40.
 Tulips signed — 120-140; 45-55; 90-110

98a, b, c and d Nineteenth century quilts in good condition
 start about — 100, and many are available below — 300.
 Rare, very old or exceptional folk art examples
 are more expensive.

99a Signature quilt — 125-150
 b Rope key — 20-30

100 a and b There are many inexpensive handmade rugs and
 mats available that can be used as wall hangings — 20-30

101a and b Original designs that are good examples of folk art
 are much more expensive, and although some may be
 found under — 100, most are above this figure.

102a Sewing bird — 225. Work holder — 300.
 Pincushion — 175
 b Sewing box — 35-45. Needlecase — 8-12.
 Set of tracing wheels — 25-35

103a Macrame shelf — 60-75. Tintype in case — 35-45.
 Brass dated lamp — 75-90
 b Painted wood shelf — 100-125. Left lamp — 275-300;
 right lamp — 150-175
 c Walnut shelf — 50-60; Victorian flower stand — 60-75

104a Shoehorns — 15-20
 b Shoe lasts, set — 40-50
 c Spigot, hand carved — 20-30. Spiles — 5-10

105a Shoulder yoke — 30-50
 b Logging sled — 125-150

106 Skates — 125; others are about — 45 up

107a Tobacco cutters, left — 140-175; right — 50-65
 b and c Cutter — 60-75

108a Towel rack — 35
 b Towel rack — 300

109a Seed drill — 125-150
 b Garden reel — 125-150

110a Bookbinder's press — 65-80
 b Croze — 40-50
 c Traveler — 25-40
 d Wooden compass — 100-125
 e Bit braces, left — 400-450; center — 250-300;
 right — 250-300
 f Saw — 50-75

111 Tools, left to right; Weeding iron — 35-45.
 Cant hook — 20-25. Rake — 25-30. Flail — 35-50.
 Shovel — 85-125; Fork — 75-100

112a A-level — 100-125
 b Frame saw — 50-60

113a Fence-wire tightener — 30-40
 b Oilstone in wooden case — 25-35.
 Whetstone holders — 80-100

114a Conestoga wagon jack — 200-250.
 Hand forged carriage jack — 140-160.
 Wooden carriage jack — 20-30

115a Weathervane — 1400 and up for comparable quality.
 b Wooden trough — 85

116a Flax brake — 125-150
 c Spinning wheel — 225-325 average.
 The one shown — 625
 e Niddy noddy — 125-150; others start about — 35
 f Hackles — 30-40. Decorated and unusual ones are
 much more.

117g Click reel — 90-110. Skein of flax — 3-5
 h Barrel cage swift — 125 up

118a Tape loom — 300-350
 b Scutching knives, each — 15-20
 Bobbins — 10-15
 Boat shuttles — 30-40; others start
 about — 20. Fish net shuttle — 5-10

119a Wooden plane — 125-150
 b Ball in cage whimsey — 30-40; others start at — 20
 c Miniature grain cradle — 25-35

120a Whatsit, handle — 40-50
 b Reel — 150-175. Knife — 25-35
 c Six spout funnel — 10-15. Punch — 15-20.
 Wooden piece — 15-20
 d Mold — 45-55

Value Guide to
Primitives & Folk Art, *our handmade heritage*
Copyright © 1979 by Catherine M. V. Thuro
This Value Guide or any part thereof may not be reproduced
without the written consent of the author and publisher.

Published by

COLLECTOR BOOKS Box 3009 Paducah, Kentucky 42001
Published simultaneously in Canada by THORNCLIFF HOUSE.

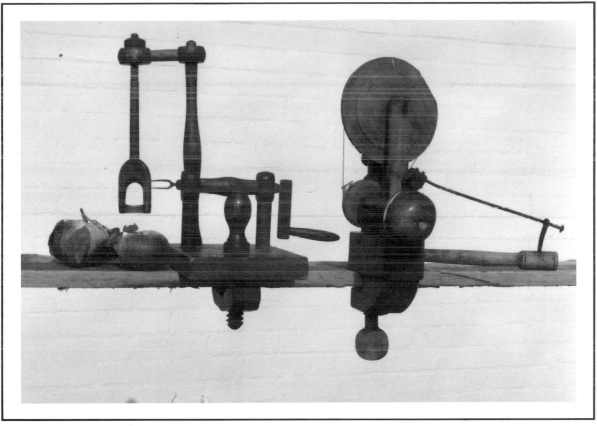

a. The more complex parers above have hand-forged iron and lathe-turned wood parts. Other examples of the one on the left have been seen. It is attributed to the Shakers and stands 13¼" above the table. The one on the right, with wooden nuts and bolts to adjust the tension on the pulley, is 12½" above the table.

b. To use the large parer with the wooden gear, one would sit on the end of the 29½" board placed on a chair or a bench. Apple peels would drop into a bucket below. The other parer was strapped to one's knee, and the small hand-held blade could be used with either one.

a. Apple parer, quarterer and corer

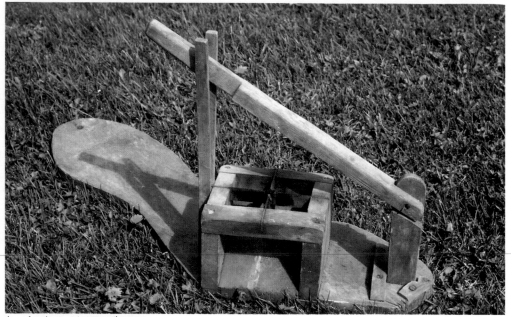

b. Apple quarterer and corer

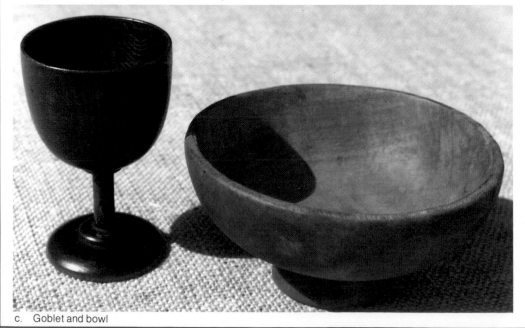

c. Goblet and bowl

d. Apple parer detail

(a) Apples were pared, quartered and cored with this unusual model. A long rod with a fork on the end held the apple. The blade attached to the strip of steel was held against the apple as it was rotated. When the peel was removed the apple was pushed into the sharpened tin cylinder with four arms held in the wooden box at the back. This part projected over the edge of a table so that the quartered apple sections would drop into one bucket, and the core pushed out the end into another. (fig. d.)

(b) This homemade apple quarterer and corer was doubtless used along with a wooden apple parer. The straight blades have been made from a steel ruler. In the center of these is a truncated cone to allow the core to drop into a bucket, while the quarter sections drop into another at the side.
As with the parer on the previous page, one would sit on the base board placed on a chair or bench.

(c) Both goblet and bowl were turned on a lathe. Many wooden goblets made in the latter part of the 19th century were painted and sold as souvenirs.
Reproductions may be difficult to distinguish, however one characteristic of an old piece is its relatively lighter weight.

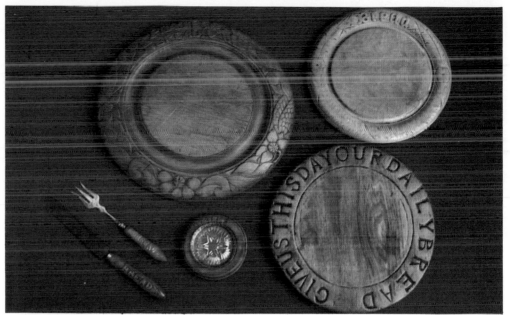

a. Breadboards, butter dish, bread knife and fork

(a) Breadboards started their popularity in the late 19th century when it became fashionable to cut bread at the table. Many boards have carved or pressed designs around the perimeter. The upper right board has a carved pattern, and the other two express extremes of craftsmanship.

Wooden butter dishes and bread forks are seldom seen, but bread knives are common.

The largest, slightly oval breadboard is 3" thick and 15¼" at the widest part, and the one at the bottom of the picture is 1" thick and has a diameter of 12½".

(b) The small splintered brooms or whisks, about 6" long, were used as beaters for eggs or cream, and the larger ones for cleaning or scouring pots. They were made by white men and Indians. Hearth brooms made in the same way are shown on page 58. Recently brooms of this type have been sold on Indian reservations.

To make them, a small birch branch was soaked in water, and the outside part of the end was splintered. The core was then removed, and the splinters were tied together. One or more successive layers were splintered from the handle, bent over the broom head and tied. The broom was then trimmed.

(c) Broilers or gridirons were used to broil meat or fish in the fireplace. They were round or rectangular, and some had revolving cooking surfaces. The bars were sometimes grooved to channel the fat to an attached cup.
Early 19th century.

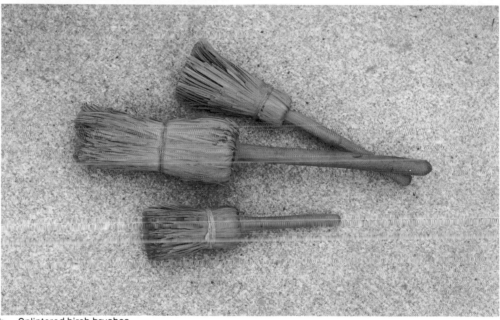

b. Splintered birch brushes

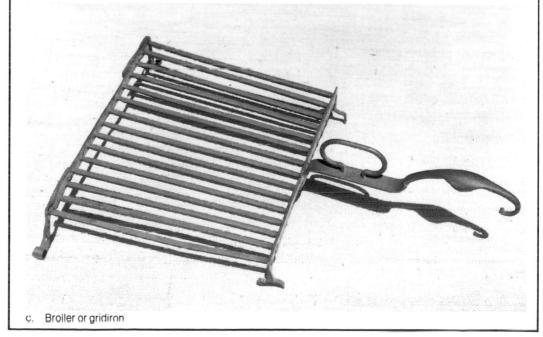

c. Broiler or gridiron

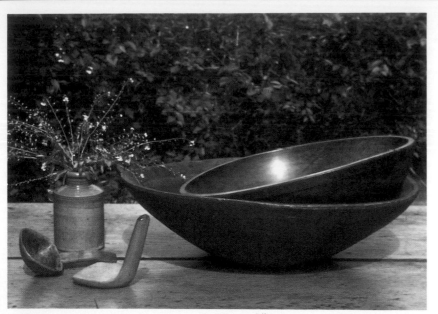

a. Butter and chopping bowls, butter workers or paddles

(a) Large bowls were used to work butter, to hold grease and fat, to make bread, as chopping bowls or for whatever other use they seemed appropriate. Close examination may determine prior use.

The green maple bowl has its original paint on the outside, but has been refinished inside. Usually earlier, and less commonly found are the ones fashioned by hand with a hand adze or scorpe. These bear tool marks on the inside although the outside may be smooth. The one with original red paint has these characteristics. It has never been refinished, and shows chopping marks and grease stains.

Early hand-carved butter workers or paddles have many variations. The one with the sharply-angled handle is associated with the Maritimes.

b. Butter mold, prints and rollers

(b) Butter molds, prints and corrugated paddles called butter hands, Scotch hands or butter rollers, were used to make butter fancy, and perhaps to identify butter made by one family at the market. The great majority were factory made with the design either pressed into steamed wood with metal dies, or by carving out a design that was stamped or drawn on the surface. Factory-made prints and molds were made from the mid-19th century on. Butter rollers were used to make ridged butter balls that were popular from the late 19th century into the 1920's.

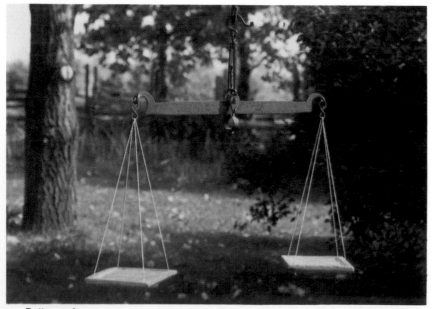

c. Butter scale

(c) Butter scales were used to weigh butter at the market. Wooden trays were often balanced by the addition of small lead weights, or in the case of the one shown, with holes drilled on the underside. This one appears to be a married piece. Originally the beautifully wrought and painted iron part would likely have had chains and metal trays for weighing heavier objects. The wooden trays which have an inscribed hex design would probably have been suspended from a wooden balance beam.

a. Cheese knife

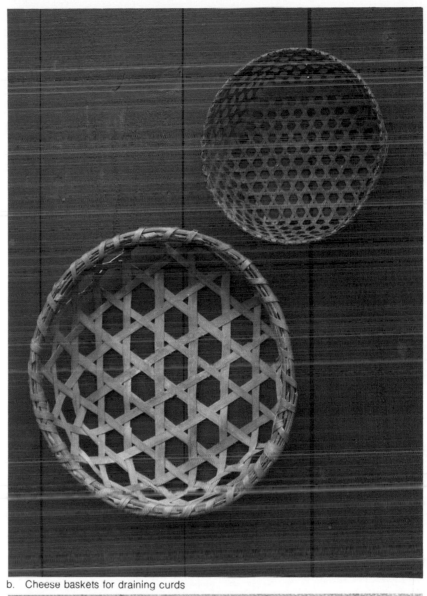

b. Cheese baskets for draining curds

(a) Cheese knife made from a file.

(b) Hexagonal-weave cheese baskets were used to drain the whey from the curds. The baskets were set on a ladder or rack placed over a tub. They were lined with cheesecloth, and the curds poured in. After they had drained they were ready for the cheese press.
Wooden cheese drainers were made in many styles.

(c) Food choppers generally had single blades. They came in a variety of shapes, and are often used as wall decorations in kitchens today. This unusual three-blade chopper that combines wood, wrought iron and sheet metal has a rugged handmade appearance. It is 9½'' long, 3¾'' wide and 5¾'' high.

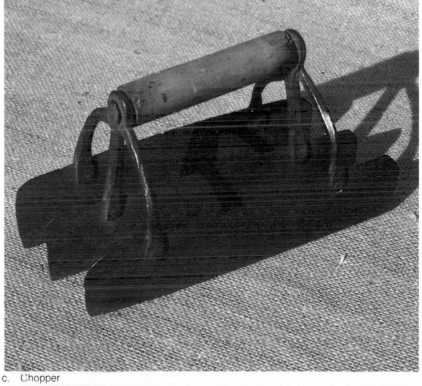

c. Chopper

a. Butter churn

(a) Butter churns were made of earthenware or wood. The wooden-stave churns were the most common. After the cream was poured into the churn, a long-handled dasher with crossbars on the bottom was placed inside. The lid was put on, and then began the long strenuous task of plunging the dasher to make butter. This task was usually performed by the "weaker" sex! A few churn lids had a small cylinder that projected above the hole to help prevent splashing. This graceful funnel top is very unusual.

(b) and (c) About a dozen patents for coffee mills or grinders were issued in the U.S. before 1850. The grinding mechanism in each of these mills, and perhaps all the metal parts of the one on the right, could have been factory made. The other parts have obvious handmade characteristics. Other examples of these two designs have been seen, with variations in proportion.
The backboard of the very rare one on the left is 14½" high. The paint is very old, and possibly original. Circa 1800.
All examples I have seen of the mill on the right have been made of cherry. It is a rare type, probably early 19th century.

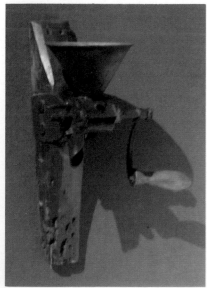

b. Coffee mill

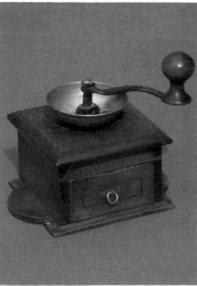

c. Coffee mill

a. Corn husking peg

a. Corn-husking pegs were made of bone, horn, wood, brass or iron. Most had leather straps, or were attached to a glove. The majority found today appear to be homemade although patented metal ones were manufactured. 19th and early 20th centuries.

b. Egg candler

c. Dish drainer

(b) Strong sunlight is needed to sort out stale or infertile eggs with this egg candler.
(c) Dish drainers were made of wood or wire in the pre-plastic days.

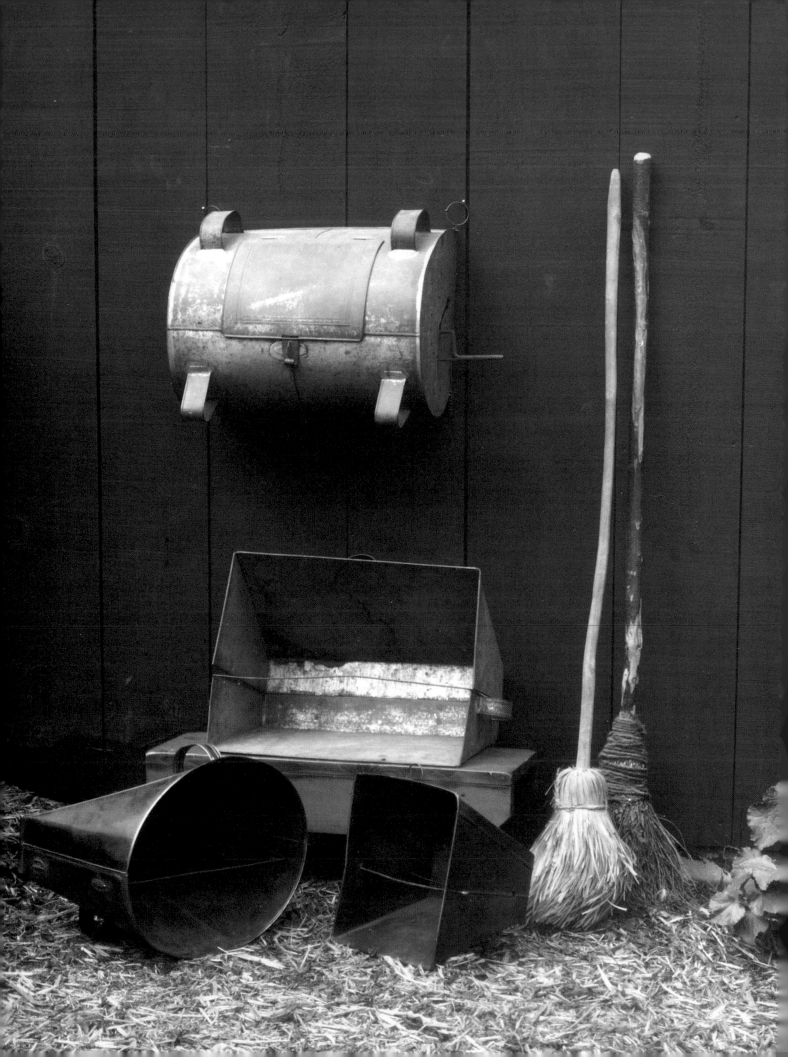

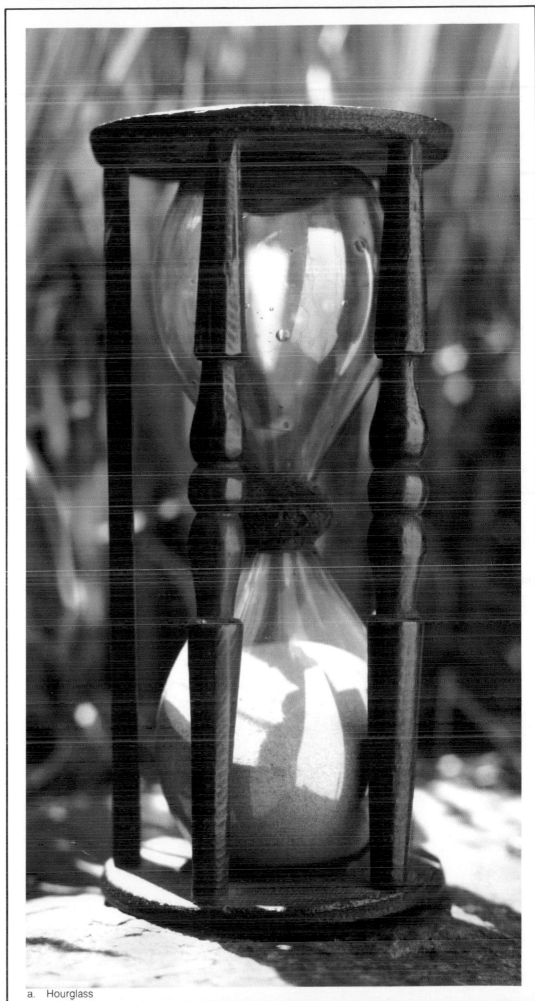

◁ Fireplace ovens shown opposite, roasted or baked with direct and reflected heat. Some had spits, a concave bottom to catch the drips, and a door to check for "doneness" Some had racks or shelves for cakes etc., and others were especially made to roast apples or small birds. Splintered hearth brooms could have been used in other areas. They are further described on page 53.

(a) Early hourglass timers were made of two free-blown glass parts. One part was filled with sand or crushed dried egg shells and the two pieces were fastened together with leather or wax. They were then placed in a frame as shown. The single straight-sided wood post is typical of this type, and may have been intended to hang flat against a wall. This type of 18th century hourglass is very rare

a. Hourglass

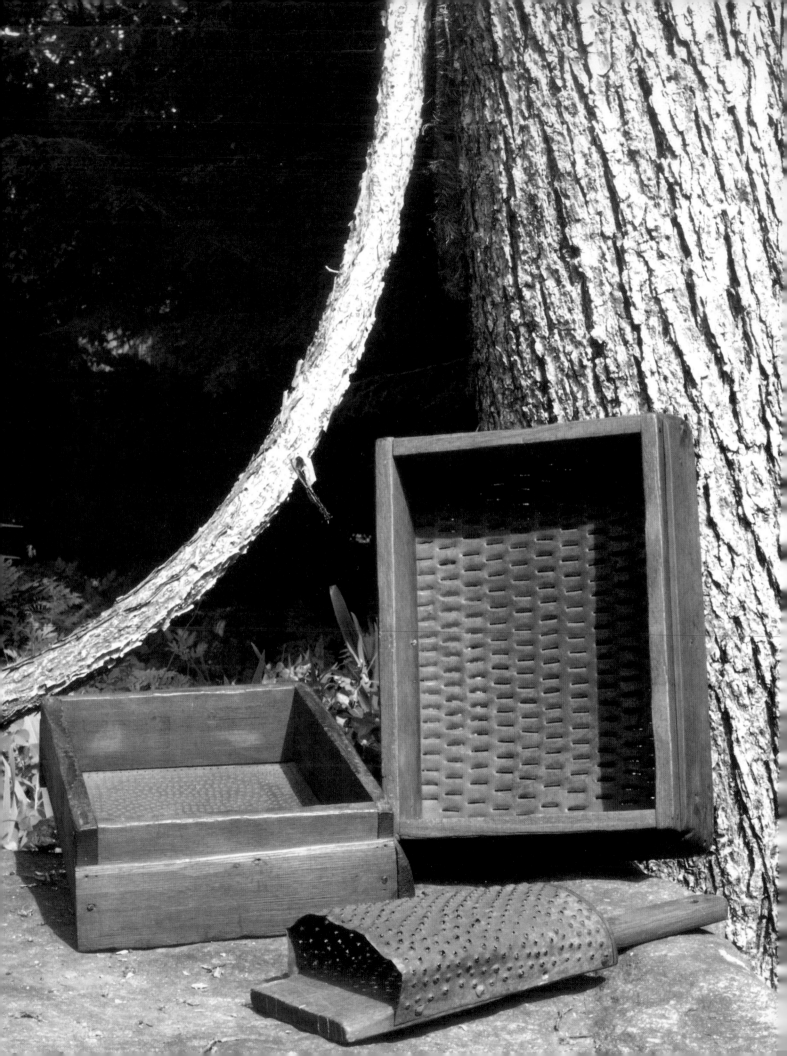

b. Cast iron tea kettles

◁ Opposite
Pierced-tin graters made in a box form, served also as a sieve or sifter. The nesting pair opposite would simultaneously separate solids of two sizes. The smaller grater is a typical homemade early type. Old pierced-tin lanterns were sometimes re-cycled for this purpose. These are good examples of currently popular make-do collectables. All graters illustrated are early 19th century.

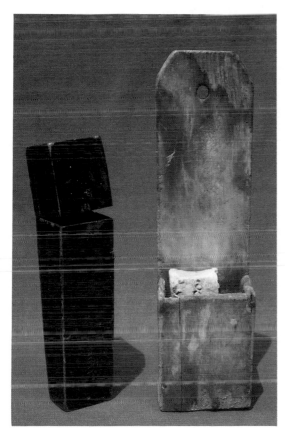

a. Knife box and knife board

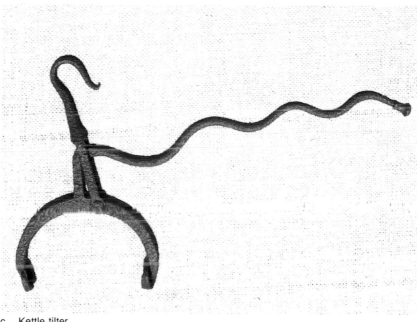

c. Kettle tilter

(a) Knife boxes were used to hold knives. There were simply-made ones for the kitchen like the one on the left, and finely-crafted ones for carving knives in the dining room.
On the right is a knife board. In the days before stainless steel, kitchen cutlery had to be regularly cleaned with a "Bath brick" or other abrasive, that was kept in the knife-board pocket. The board was placed flat on a table, and kitchen knives and cutlery were scoured on the upper part. The well-used ones will have a depression in that area like the one shown. Most boards found today were used in the last half of the 19th or early 20th century. The nails will help indicate their age.

(b) Two cast-iron tea kettles used for boiling water in the fireplace or on the stove. The large cannonball kettle on the left has a built-in tilter. Hung on a crane or trammel, the kettle would be heavy, and too hot to handle. The tilter would allow the pot to be easily tipped for pouring. The kettle on the right is a more common type. Both are early 19th century.

(c) This kettle tilter is an interesting example of wrought iron work. It would hook onto a crane or trammel, and the kettle handle would be set on the two small hooks. The long serpentine handle would give good leverage, and would also be well away from the fire. 18th or early 19th century. Kettle tilters vary considerably in form, and some might be difficult to identify.

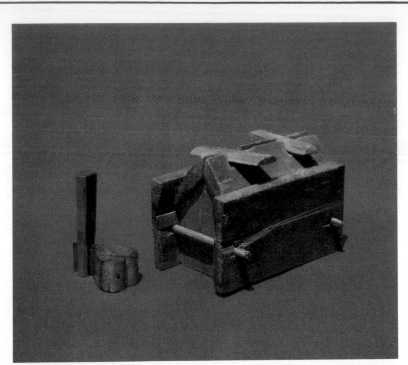

a. Maple sugar molds

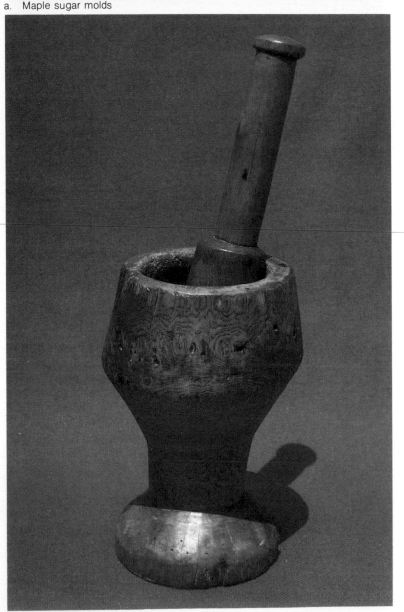

b. Mortar and pestle

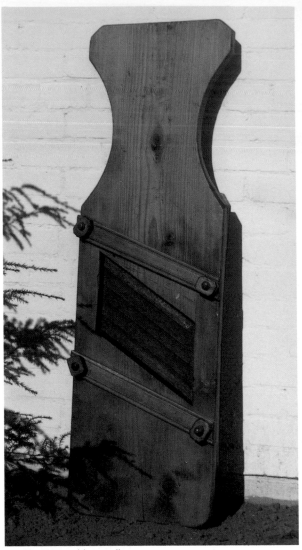

c. Kraut or cabbage slicer

(a) Carved maple sugar molds from Quebec show as great, if not greater variety of shapes and sizes and subject matter than butter molds. The mold on the left has a heart-shaped piece of wood ¼'' thick carved on both sides. There is a cross in the center and chip carving around the edge. It is nailed in the center of the tin form that is held together by the wooden peg. Both sides were used to make two ½'' thick decorated cakes. The interior walls of the 7'' long house mold on the right, have windows, door and chimney details carved in relief. The finished product will have these impressed in a solid block of maple sugar. Molds of up to 10 pieces, held together with wooden pegs, formed whole objects such as houses, trains and animals. Among religious and secular motifs depicted on small cakes are Bibles, crosses, angels, chalices, animals, fish, flowers and hearts (broken or otherwise). Many geometric designs are seen. Sugar molds were also made in New England, and some reproductions have been reported.

Continued on page 63 ▷

a. Wooden pitchers were used as liquid measures, and as drinking vessels. These are often called noggins, after early drinking vessels with faces on them, hence the use of the word noggin for head. These very handsome ones were made out of one piece of wood.

The lathe-turned funnel and tiger maple potato masher are fine examples of 19th century woodenware.

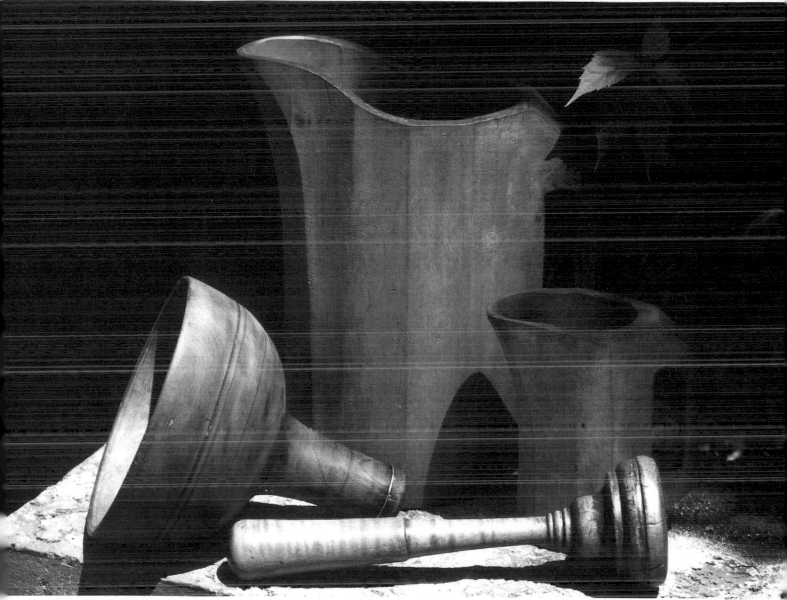

a Noggins, funnel, potato masher

(b) A mortar and pestle was used in almost every household and by doctors and druggists for preparing medicines. They ranged in size from a druggist's one of a few inches, to one a few feet high, made from a hollow log for pounding corn. This 11¼" mortar has been made from a tree trunk, and the annual rings at the widest part (7") represent over 100 years growth! The center was burned out, and the pestle is made of the same wood.

(c) Kraut or cabbage slicers were made on a large scale to facilitate making great quantities of sauerkraut. The underside view of this 14" x 45" board shows its interesting construction. On the top side there are tracks along the outside edges that guide a box holding the cabbage as it is pushed back and forth over the iron cutting blades. There is also a stamped geometric design similar to those used by blacksmiths, and a carved heart with the initials G.D.

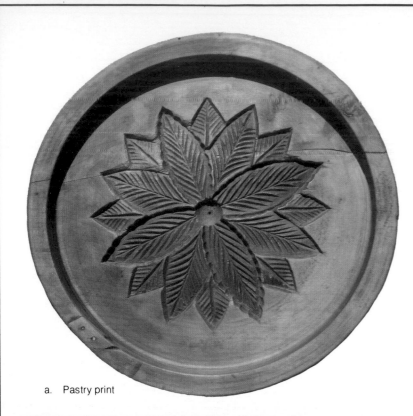

a. Pastry print

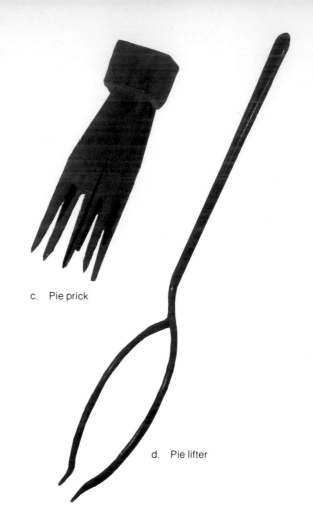

c. Pie prick

d. Pie lifter

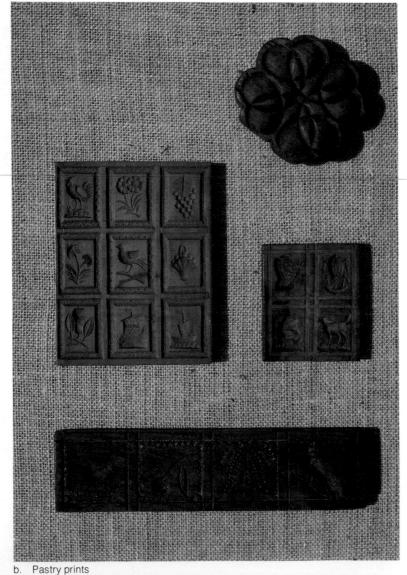

b. Pastry prints

(a) and (b) These pastry prints left their impressions on cookies, candies and cakes. Pastry was rolled into thin sheets, pressed onto the mold and trimmed. Other prints were pressed onto the dough. The large print (a) is the size of a pie, about 9" in diameter. The other prints show a good variety of patterns. Marzipan, an almond pastry type of candy was pressed on a long rectangular print like the one at the bottom of picture (b).

Most of these 19th century prints are from Pennsylvania.

(c) An interesting chip-carved pie prick from Pennsylvania. 19th century.

(d) Pie peels were usually flat paddles similar to a bread peel, except for a short handle. This unusual hand-forged one appears to be a forerunner of the factory-made wire pie lifters.

The beautifully-detailed pot lid opposite, ▷ in bright metal, has a cartouche below the bird that is essentially the same as that on the spoon on page 68. Iron pieces that have been ground and polished to a silvery finish are known as bright metal. This was usually the work of a craftsman known as a whitesmith.

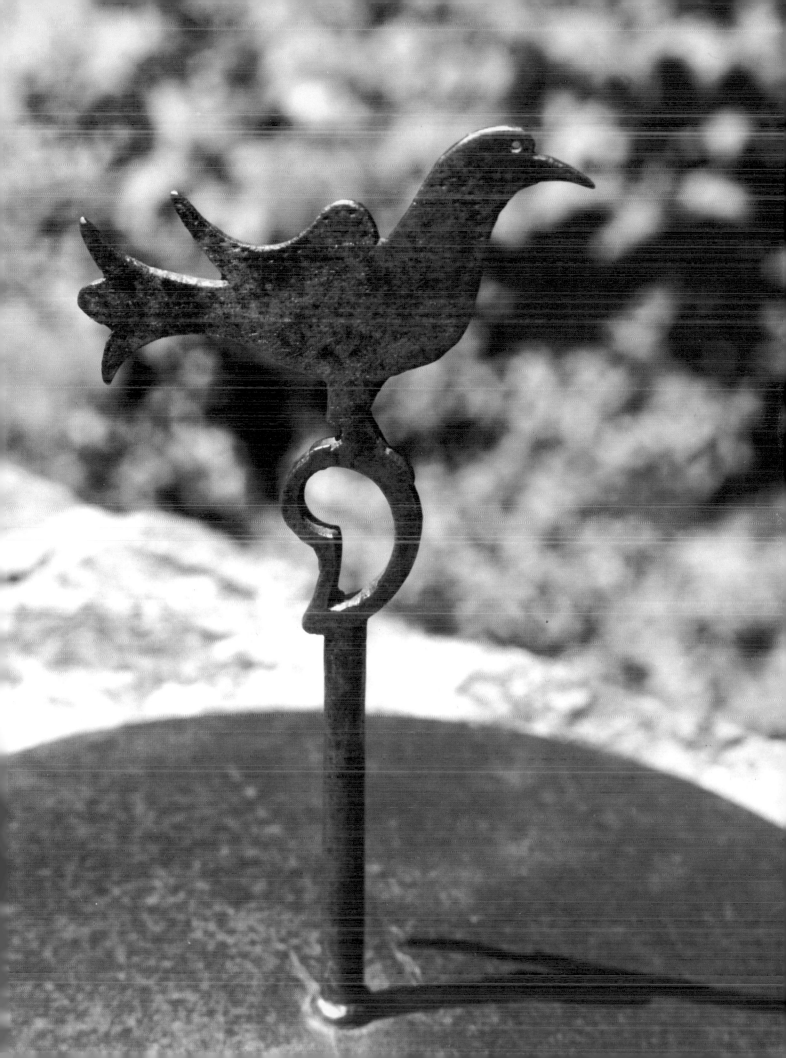

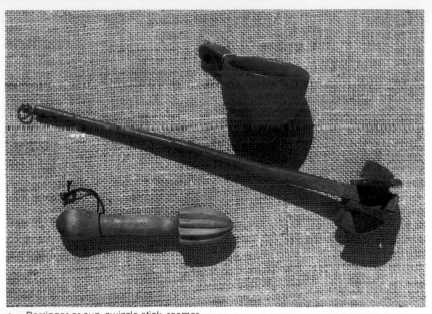

a. Porringer or cup, swizzle stick, reamer

b. Swizzle sticks

c. Rolling pins

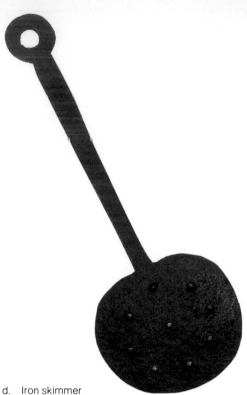

d. Iron skimmer

(a) Small-handled wooden cups were used as porringers or as drinking cups. Some were said to be voyageur's cups that were tied to the belt of the canoeist so that he could readily scoop up a drink of water. The long-handled swizzle stick, used for mixing drinks, was rotated by twirling between the palms.
At the bottom of the picture is a small reamer.

(b) The top swizzle stick was turned on a lathe and chip carved. Also turned on a lathe, the bottom swizzle stick has a reamer carved on one end and a carefully detailed clenched fist on the other. This symbol of anger is usually reserved for articles of protection such as canes or knives, and in that respect is not very appropriate here.

(c) Nineteenth-century rolling pins were usually hand turned on a lathe. They are less precise than those sold today, but are essentially the same. The two children's rolling pins are 7'' and 9¾'' long. The 9¾'' one has separate handles held together with a square iron pin that has been flattened at the ends.

(d) Skimmers were used to remove solids that rose to the surface as a result of a chemical reaction (fermentation) or heat (boiling). They were made of tin, iron, brass, copper or wood.

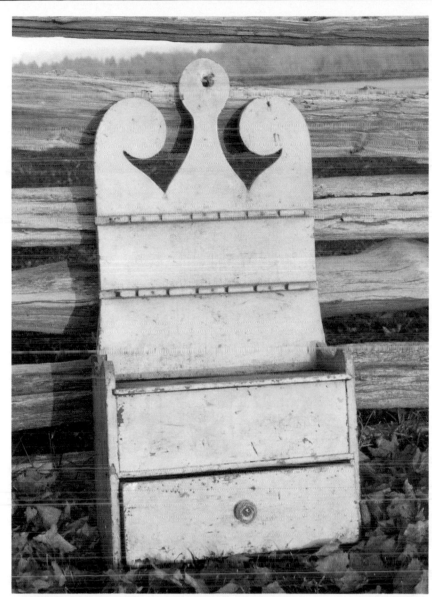

a. 19th century spoon rack

(a) This 19th century spoon rack has a storage compartment with a lift top above the drawer. Knives and kitchen gadgets would be kept here.

(b) An 18th century carved spoon rack, 10" high x 9½" wide. There is a similar one at the Du Pont Winterthur Museum. Other pieces such as bed-smoothing boards that have the same type of carving and color have been seen with late 17th and early 18th century dates.

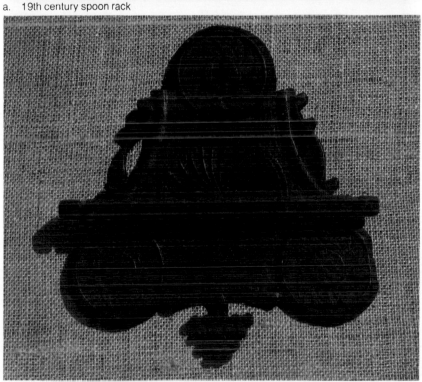

b. 18th century spoon rack

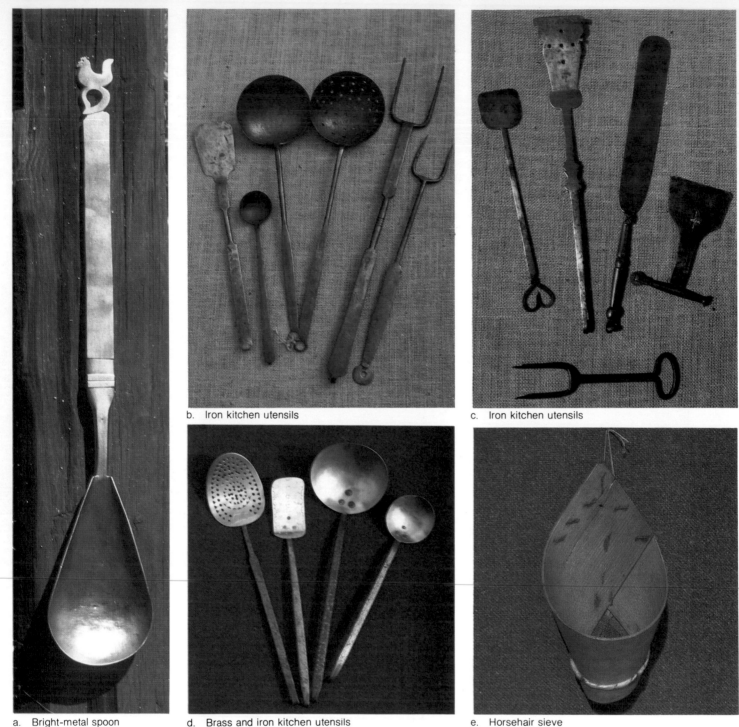

a. Bright-metal spoon

b. Iron kitchen utensils

c. Iron kitchen utensils

d. Brass and iron kitchen utensils

e. Horsehair sieve

(a) A beautifully designed and finished spoon 22¾''
long. See pot lid on page 65 for a similar detail below
the rooster.

(b) Iron kitchen utensils include from left to right a
spatula, tasting spoon, ladle, pierced ladle, meat fork
22¼'' long and another meat fork 17'' long.

(c) Most of these pieces are typically Pennsylvania
wrought-iron types. Left to right are a turner with a
heart-topped handle, a very decorative fish slice that
could be English, a spatula and a chopper, possibly
used for decorating pies. At the bottom is a meat
holder to hold a roast while slicing it. This is a rare
wrought-iron piece.

(d) Brass kitchen utensils with iron handles. Both
brass and iron are decorated.

(e) and (opposite) Horsehair sieves or sifters were
made by the Shakers. A dealer reports bringing
several back from Europe, so they were apparently
made there also. The horsehair woven on a special
loom, was sometimes dyed so plaid patterns like the
one opposite could be made. The small one above,
9'' high and 5'' at the widest part, could have been
used to sift flour over pastry or bread. Druggists used
small ones when preparing prescriptions.

Horsehair sieve ▷

a. Wooden scoops were used for the many dry ingredients that were packed in barrels and boxes.

b. This attractive cherry spice cabinet with contrasting drawer knobs can be very functional in a kitchen today. It is 13¼'' wide x 11½'' high and 7'' deep.

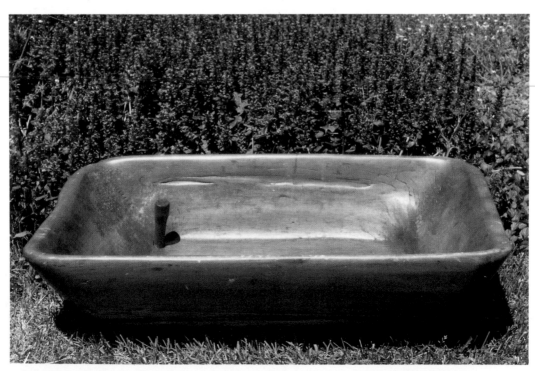

c. Wooden sinks are rarely found today. They could have been emptied into a pail, or set over a drainpipe that carried the waste water outside. Before a dealer refinished this pine sink, the wood was grey and swollen from water and lye, and the original plug (shown) was almost impossible to pry loose. The top is 16'' x 24'', and the height is 6''.

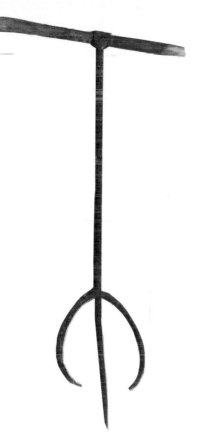

a. Sugar auger or fruit loosener

(a) Augers, which ranged in size from about 12'' to 24'', were used to break up sugar or to loosen dried fruit packed in barrels or tubs. The first three auger patents were issued in the 1870's to three different men, all from Waterloo, Iowa. These patentees described their inventions as fruit lifters or looseners. Advertisements however mention the alternate use for sugar. Many blacksmith-made ones are still found today with a wide variety of spiralled ends.

(b) It would appear that this cutter, with its beautifully engineered handle, was probably used in the dining room for cutting chunks of loaf sugar into small pieces. The base (partly broken) would catch fine pieces. The blade comes down onto a channeled bar with finely-scalloped edges. Another cutter has been seen with a delicately detailed straight blade and handle, and a similar elevated base.

(c) Most sugar cutters, or nippers as they were also called, were imported from England in the late 18th century and throughout most of the 19th century. Table models like the one shown, and the more common hand-held type were beautifully made in bright iron.

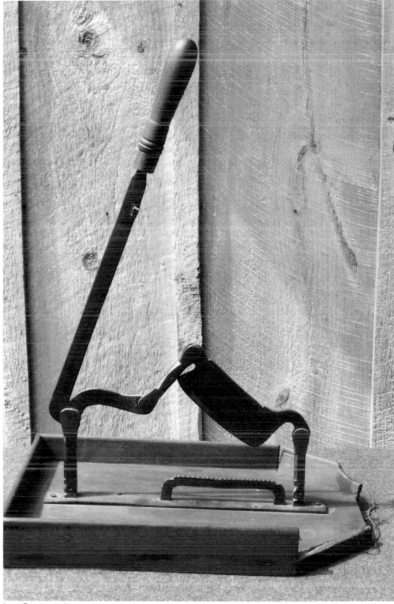

b. Sugar cutter

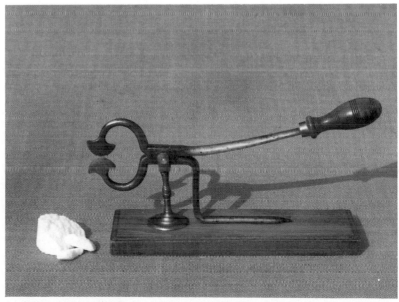

c. Sugar cutter or nippers

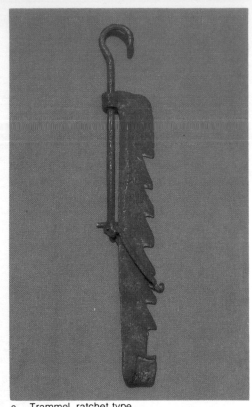

a. Trammel, ratchet type

(a) and (opposite) Trammels hung on a fireplace crane were used as adjustable hooks for pots and kettles. The most common ones found today are the ratchet type (a). Many of these have been imported in the last few years.

Opposite are chain trammels, one of which has flattened links.

The peel with a ram's horn end on the handle was used to remove bread from the oven. Beside this is a long-handled fry pan.

Many iron pieces have been imported, and it is difficult and sometimes impossible to determine the origin of an unmarked piece. For this reason, any name or mark of identification adds considerably to the value of the piece.

The embossed lettering on the cast iron kettle reads
WOOD, BISHOP & CO
55
BANGOR ME

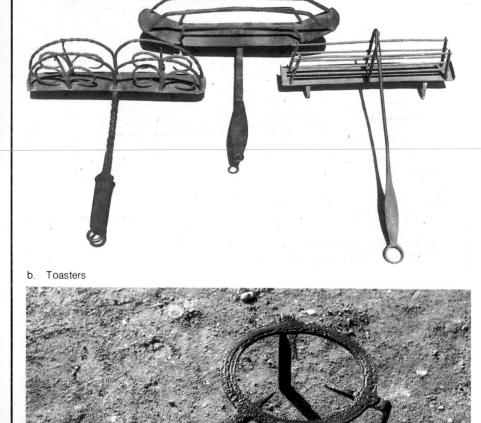

b. Toasters

c. Trivet

(b) The iron toasters are typical of those used on the hearth in the 18th and 19th centuries. Toasters with more elaborate or artistic iron work, like the one on the left, are much preferred by collectors.

(c) Pots, pans and kettles were heated on trivets placed over hot coals on the hearth. They usually had three feet and a round, square or heart-shaped top.

Opposite ▷
Trammels, peel, fry pan and kettle

a. Lye log

a. Homemade hard soap

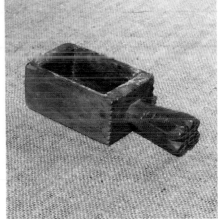

b. Soft soap scoop

Soap making was a chore that was undertaken twice a year. Fat and lye, the basic ingredients, were readily available in the home. Fat was saved and rendered for soap, and the lye was obtained from hardwood ashes.

To obtain the lye, alternate layers of straw, which acted as a filter, and ashes with perhaps some unslaked lime, were placed inside a barrel or hollowed-out log such as the one shown opposite. A section of a tree trunk that had decay in the center was burned out, and then chiseled smooth. These hollow logs are essentially the same as the ones used as a large mortar for hulling corn.

The log was placed on a stone (c) that was grooved to allow the lye solution to drain into a tub. Few of these stones are found today, and yet many of them must still be around old houses or farms, perhaps covered by a few inches of earth. Boiling water followed by cold water was poured over the straw and ashes, and the result of this leaching process was the lye solution. If the solution was the correct strength, an egg would float with only a small area above the surface. Water could be added to dilute a solution that was too strong, but a weak one had to be thrown away.

This was the first problem encountered in soap making. The second involved heating the rendered fat and lye solution to make soft soap. The rendered fat was melted in a large cauldron, like that in (d) or even larger, and the lye solution was added gradually. The addition of this solution, the way in which it was stirred and the amount of heat from the fire all played a part in the success of the operation.

When the soap was ready it was stored in tubs and kept in the summer kitchen. Small soft-soap scoops like the chip-carved one (b) were filled for use in the laundry or kitchen.

The recipe for hard soap varied slightly. Both hard and soft soap are still made in some areas today. The piece of homemade hard soap on the Bennington-type soap dish (a) was made recently.

c. Lye stone

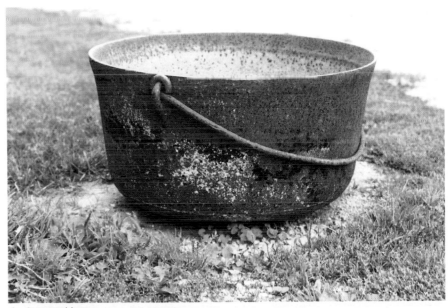

d. Iron cauldron

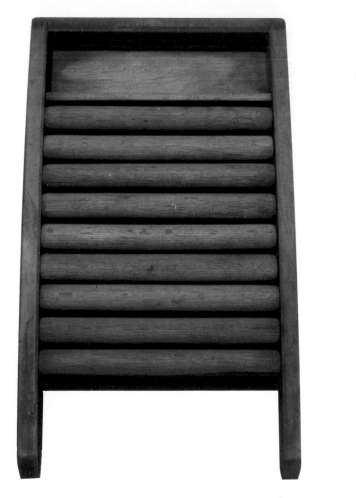

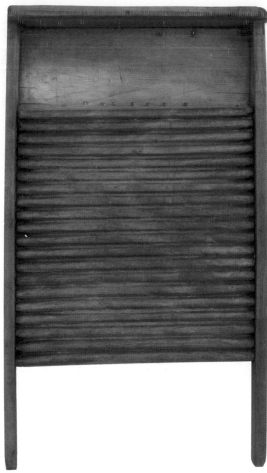

a. Wooden washboard
(Courtesy, Pennsylvania Farm Museum of Landis Valley.)

b. Corrugated wooden washboard

Articles from a 19th century laundry contrast greatly with those used today, and can lend warmth and interest when used to decorate a utility or laundry room.
The first U.S. patent for a washboard was obtained in 1833. On the left is one dated 1846. It has separate rollers held tightly together in the frame. Similar ones have revolving rollers. The corrugated wooden washboard on the right was probably factory made. Some washboards had a scrubbing surface made with rows of spools, similar to a spool bed.

Glazed pottery washboard ▷

Pottery washboards with sponged or spattered slip design are popular with pottery collectors as well as those who collect laundry items. Unfortunately, many found today are cracked or have areas of the glaze worn off. The one opposite is in excellent condition.

a. Glazed pottery washboard

a. Goffering iron, sad iron and trivets

b. Wooden fluter

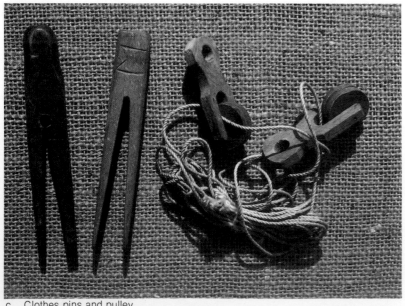

c. Clothes pins and pulley

(a) At the top of the picture is a goffering iron. An iron lug on the end of the hand-wrought handle was heated in the fireplace and then inserted to heat the holder or barrel. This was used to iron ruffs, the gathered fabric, lace or embroidery that was used to trim clothing.

The small cast pressing iron is known as a "sad iron", not because of an attitude towards the chore, but because "sad" meant heavy or solid. Some of these had cast iron handles and others, like the one shown, had handles fashioned by a blacksmith. They were heated in the fireplace, on a stove, or later on small kerosene stoves designed for this purpose.

Trivet is the name given to a pressing-iron stand as well as for the larger ones used for pots on the hearth. Mass production of cast-iron trivets began in the 1850's. Before that they were made in brass, copper and wrought iron. The heart-shaped brass trivet with copper feet has the inscription S.R.1838 engraved within a border. It has a replacement wooden handle.

At the bottom of the picture is a trivet made by a blacksmith in a whimsical mood. He put shoes on its feet! It has also both a cut-out and a stamped M or W, and a scalloped edge.

(b) Fluters were used to make tiny pleats in starched fabric. Most were factory produced in metal, or in a combination of wood and metal. Fluters made entirely of wood are rare. This use has been ascribed to the piece pictured here, and while identification is not positive, it was obviously made to make a pleated edge on something wider than the rollers. Although the appearance might belie it, the corrugated rollers mesh easily.

(c) Most clothes pins and pulleys were factory made in the last half of the 19th century, but simple ones like those shown here would have saved a few pennies, or perhaps a trip to the store in remote areas. Those with decorative carving were probably made as gifts.

Opposite ▷
The tall (37½") wooden piece is a wash dolly that was used to churn the water and pound the clothes in the wash tub. Diverse designs were created for this purpose.

Wrinkles were removed from linens and flat laundry by wrapping them around a wooden roller and then rubbing them with a plain or corrugated smoothing board like the one shown. They are sometimes confused with corrugated wash sticks that were narrow washboards or scrubbing sticks. These have a handle on the end that is a continuation of the board, and less rounded corrugations.

The wash tongs carved from one piece of wood were used to lift clothes out of hot wash water.

a. Long, spiralled shavings or twisted pieces of paper called spills, were set aflame in the fireplace and used to light candles, lamps and pipes. Spill planes, made in a variety of designs, could be adjusted for tight or loosely curled shavings.

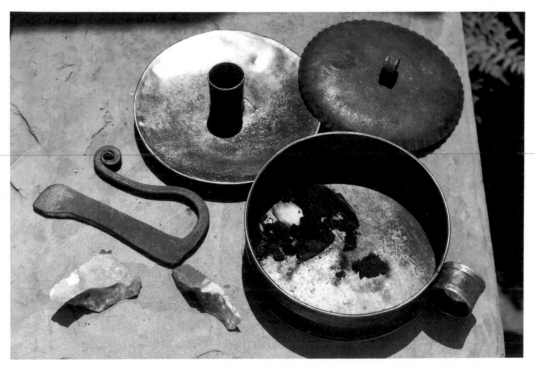

b. The tinder box was a convenient kit used to produce a flame. Sparks made by striking a flint against a piece of steel were directed onto dry charred fabric (tinder) in the box. When the tinder glowed and a sulphur tipped splinter was touched to it, both the splinter and the tinder would burst into flame. A candle held on the cover would then be lit. The handled disk would snuff out the blazing tinder, the flint and steel striker stored on top, and the cover replaced.

Opposite ▷

One of the earliest lighting devices was a holder for splints of wood that were ignited in the fireplace. Splint holders held the wood horizontally or slightly angled in a slot or spring clamp as shown in this handsome 22" one.

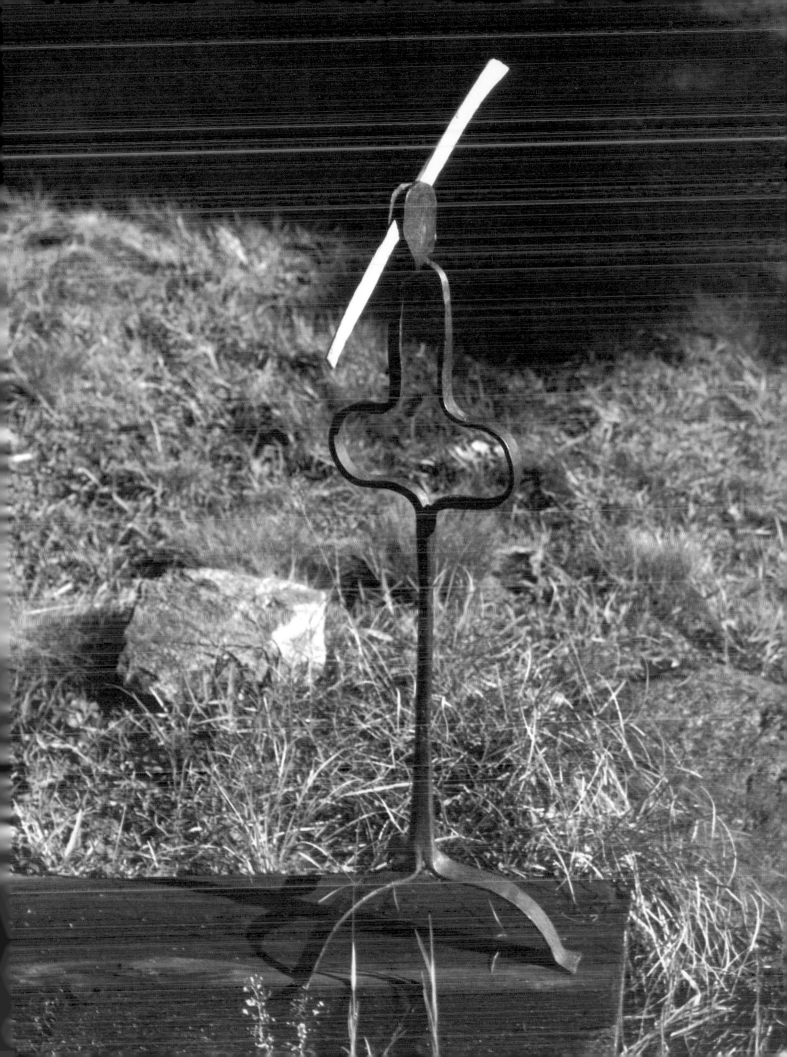

a. Rush holder

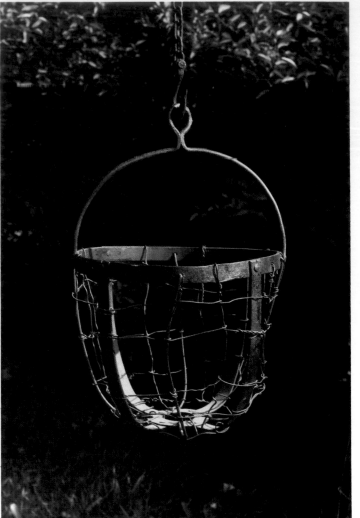

b. Basket cresset

A common bog rush, "juncus effucus", found in many areas of the U.S. and Canada, was treated to provide a small smokeless flame. This rush, cut in the late summer, was partially peeled so that a thin spine supported the exposed pith. After soaking in melted tallow or lard to impregnate the pith, the rush was ready for use.

(a) Because of the light and fragile nature of the rush, little pressure was required from a spring or clamp holder. The rush holder above is shown with a small splint of the type that like a spill, was used to transfer a flame rather than one that provided light. The candle socket that serves as a counterweight was a common arrangement.

(b) Cressets were made for use as stoves and heaters (see page 92) or for lighting purposes. Stove-type cressets were usually made with three or four feet and are therefore easy to identify. Cressets made for lighting would use brightly-burning resinous pine wood, or the longer-burning pine knots. Large basket cressets made with a handle as shown, would provide general outdoor illumination. Small basket cressets mounted on gimbals at the end of a pole, served as parade torches.
Rib-cage cressets were projected over the water at night to provide light for spearing fish. Other cresset shapes had spikes that could be driven into a wall. Diameter of cresset top is 13¾".

a. Double crusie

b. Betty lamp

Crusies and Betty lamps were pan lamps that used grease or oil for fuel, and generally a piece of cloth for a wick.

(a) The crusie above, referred to as a double crusie, is a combination of a lamp and dish to collect the fuel that would drip from the wick at the spout. The upper lamp portion is supported on a notched projection. This arrangement permits a canting action. As the fuel is consumed, the decreased amount can be kept closer to the end of the wick.
The lamp can be hung as shown, or the end spike may be driven into a wall.
Measurement from the bottom of the lamp to the top of the spike is 11½".

(b) The Betty lamp is really an improved form of crusie. A short wick tube or support was added to allow the grease to drip back into the bowl of the lamp. Most Betty lamps were covered, and most crusies were open, but there were exceptions with both.
The little rooster finial was often used, and a wick pick attached to a chain is included with many of these lamps. The spike and swivel suspension is similar to that of the crusie.
The overall height of this lamp is 9½".

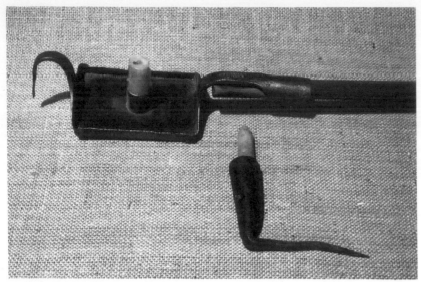

a. Baker's candle holder and spike candlestick

f. Candle box

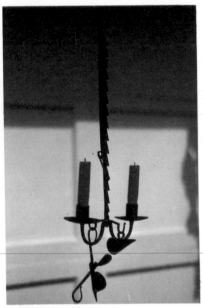

b. Candle trammel

c. Wood candlestick

d. Candle sconce

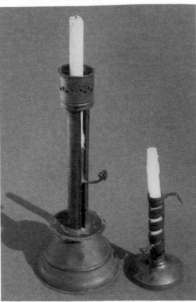

e. Adjustable candlesticks

Candles made today are essentially the same as those made centuries ago, thus candle holders are one type of antique that can be used for the same purpose for which they were originally created, without wear or damage. It should be kept in mind however, that there will be a noticeable carbon deposit on walls and furnishings with frequent use.

Lighting is a long-established area of collecting, and one where handmade characteristics are important and appreciated. Those pictured here are but a small sampling of the many forms and materials used.

(a) A rare hand-forged baker's candle holder attached to a long handle with a hook on the end to pull the baking out of the oven. Early 19th century. The hand-forged 18th century candle spike is a type that was driven into log-cabin walls or used underground in mines.

(b) An 18th century candle trammel with wick trimmers and a snuffer.

(c) The stem of this crudely-fashioned candlestick has been mortised into the base. 19th century.

(d) There were many varieties of hand-made candle sconces. The back of this one has been carved to resemble a tape loom, like the one shown on page 118. A low saucer chamberstick was usually placed on this type of sconce. About 12" high. 19th century.

(e) Both these candlesticks are adjustable: the one on the left by fitting the arm into a series of notches, and the one on the right by turning the arm on the spiralled column. They are 18th century or earlier.

(f) Considered a delicacy by mice, candles were therefore stored in wood or tin candle boxes. 19th century.

Opposite ▷
This handmade adjustable candlestand has been made with a left hand thread.

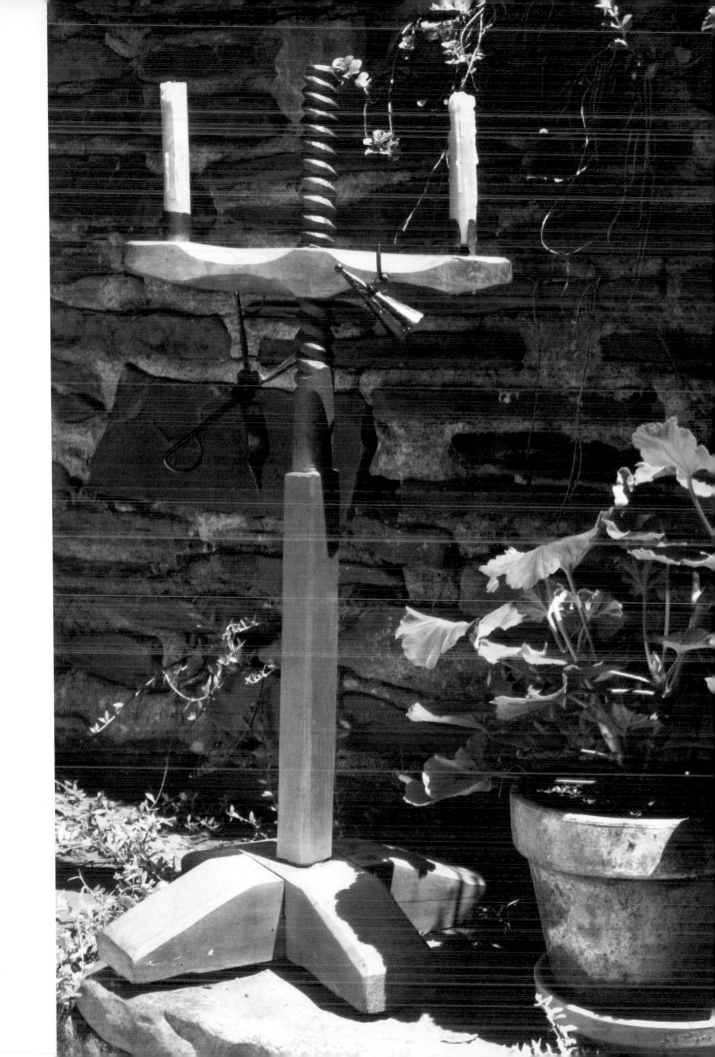

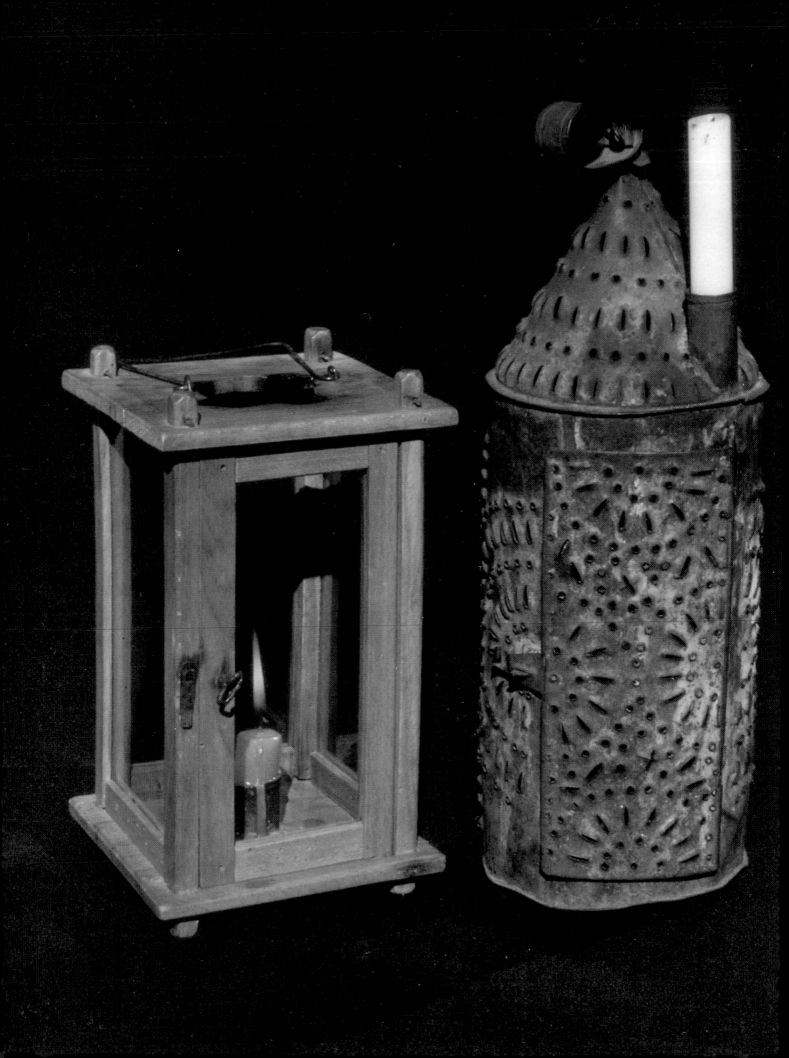

Before the late 1850's when the use of kerosene became widespread, gas or carbon-arc street lighting was available only in larger urban areas, and only to a small percentage of the population. Lanterns with whale-oil burners or candles, guided the pedestrian, the rider or the carriage.

Candle lanterns were most commonly used, and those illustrated represent three popular types. The construction of the 10" wood lantern (opposite), would lend itself to factory or shop production. It is held together entirely with small wooden pegs, and could be quickly assembled.

At some point in the past, pierced-tin lanterns gained the reputation of being the type used in the tower of Christ Church in Boston, to signal Paul Revere across the river. This story has often been ridiculed because of the feeble light produced by these wind proof lanterns. Some of these lanterns at that time, were made with several glass bullseye lenses 2" to 3" in diameter. If a lantern was used as a signal, would this not be better than one with plain glass?

Once indoors, the candle could be removed from the lantern and placed on the top as shown, to provide additional light. It is 16½" high.

Horn and mica used in early lanterns had the advantage of being shatterproof and easily adapted to a curve. The one shown here is a typical 18th century horn lantern.

◁ Opposite
Wooden lantern
and pierced-tin lantern

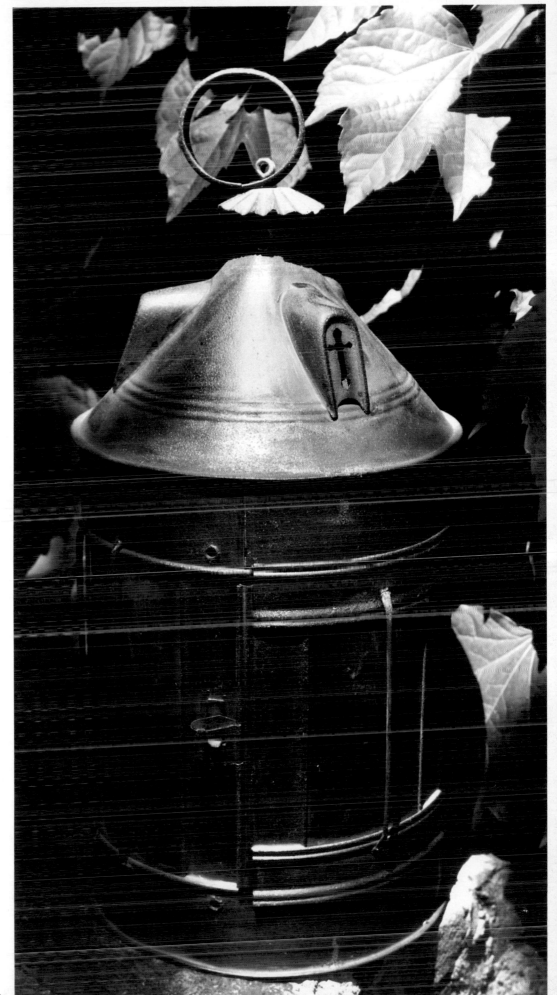

Horn lantern ▷

a. Make-do lamp

b. Beaded match holder

c. Birdseye-maple match holder

(a) The Ring Punty glass font, circa 1860, was pressed in a bowl-shaped mold, re-heated and then drawn in to form the neck or collar. This technique has resulted in the upper band of puntys or ovals, having a shallow and less distinct outline. Damage to its base has resulted in a make-do lamp that has probably more charm than the original form. Two channeled pieces of oak grooved to accommodate bands of brass wire, form the stem. The cast-iron stepped base could have been from any source, possibly a candlestick. It would appear that constant use, and oily hands have worn away most of the original blue paint. The lamp is 8½" tall.

(b) This self-dated match box, also referred to as a match safe or match holder is an example of beadwork that was popular from the turn of the century to about 1930.

(c) The tiny birdseye-maple match holder would have held only about a dozen matches.

Throughout the second half of the 19th century glass, cast iron, tin and other metals were used to make match holders in hundreds of different shapes and sizes. Although most of these were factory produced, many were handmade during the same period.

a. A liquid prism was used in schools and colleges in the 18th and 19th centuries to demonstrate the indices of refraction of different liquids. Most found today are wood and glass, made watertight with putty. They vary in size, construction and workmanship, and individual ones are difficult to date. The one above has its original red paint with gold trim.

b. In the home, scraps of fat were rendered (melted) to provide lard to be used as lamp fuel, for cooking and perhaps as a lubricant. The final step in the rendering process was to press any unmelted solid pieces to extract all the liquid lard. This was often done between two boards hinged at the end; however, the press above would be more convenient to use. About 24" long.

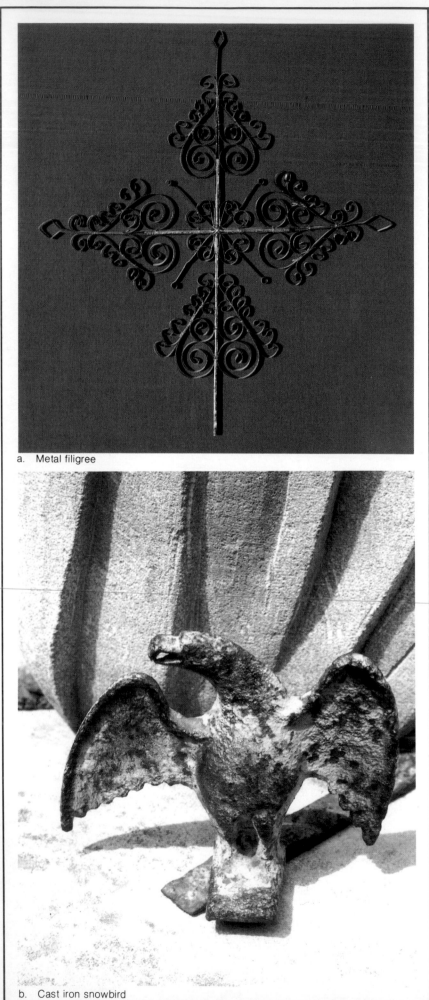

a. Metal filigree

b. Cast iron snowbird

Decorative elements saved from decay or the destruction of buildings, ships, trains and vehicles, can continue to be decorative elements in a different setting. Pieces of gingerbread, the fanciful wood trim that decorated mid- to late-Victorian houses, are often available. Carved wood or stonework, cast or wrought ironwork and decorative glass are now collected and protected and viewed from a new perspective.
This protection and enjoyment is also extended to include whole objects, or parts of objects, that were never intended to be decorative. Their shapes, textures and colors are now appreciated as an inter-esting combination of design elements.

(a) Curled strips of sheet metal, held in place with fine wire and secured to an iron armature, create this delicate metal filigree. It is 17" high, and both age and original use are uncertain.

(b) Snowbirds were fastened close to the lower edge of slate roofs to prevent the buildup of snow and ice from sliding off and pulling out the tiles. Wire loops or railings were also used for this purpose. This eagle is 5" high, and quite similar to ones that have been reproduced.

Opposite ▷
Rescued from a pile of scrap metal, this section of a wind-mill becomes a handsome wall decoration. It is a reminder of the rural land-scape with color, texture and patterns of light and shadow, all contributing to its effectiveness.

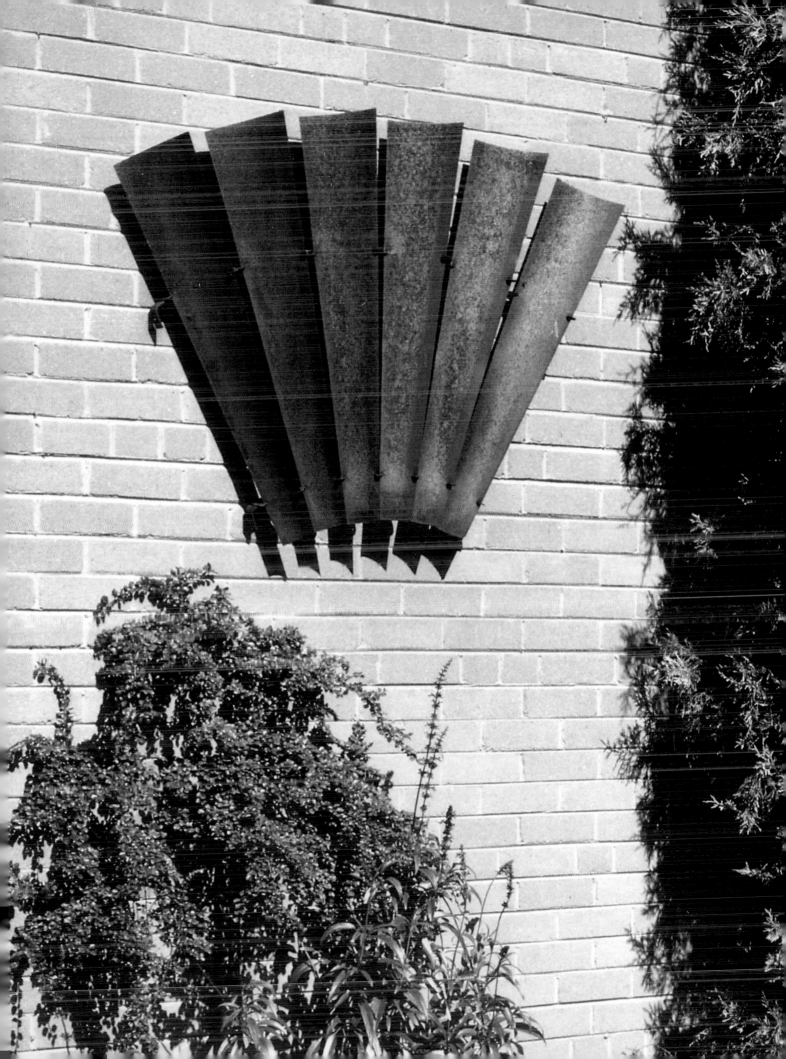

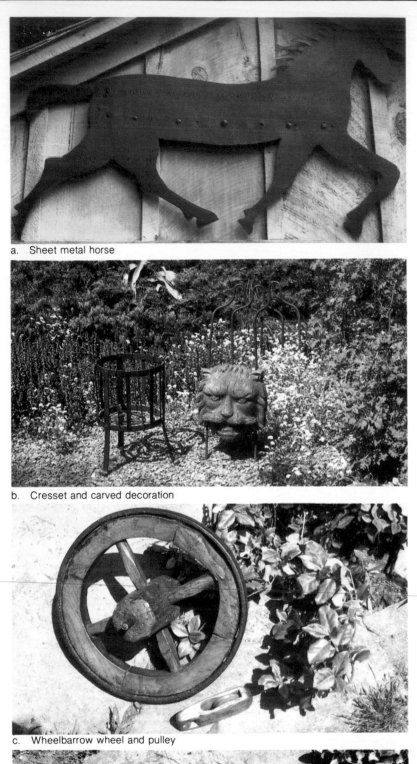

a. Sheet metal horse

b. Cresset and carved decoration

c. Wheelbarrow wheel and pulley

d. Ensilage fork

(a) Horses were favorite subjects for weathervanes and signs. This wall-mounted piece has a peculiar gait that was probably due to a compromise between the body size of the horse and the width of the metal available.

(b) Cressets or portable grates were used by tradesmen. A fire was required to dry or steam the inside of the cooper's barrels, or to melt lead for the plumber. The one shown here is 17'' high and 10¾'' in diameter.
Probably from an iron fence or gate, this decorative piece has a weathered carved and painted lion face on each side. The strong color that remains on the sheltered portions gives added depth to the features. This aspect would be lost if the piece was repainted or refinished. Overall height of the metal part is 34''.

(c) The apparent lack of a seam or join in the metal tire of the wheelbarrow wheel is a tribute to the skill of the blacksmith, and the chamfered hub and spokes add to its appeal. The wheel diameter is 11''.
The small pulley was hand carved.

(d) Four different woods occur in the fork with the hand-forged tines, however the upper arm is a replacement. It was part of a piece of farm machinery. From the tip of the center tine to the end of the handle it measures 19''.

a. Mousetrap

b. Mousetrap

The variety of mousetraps made in the last century perhaps reflected the nature of the individual that created them. There were those that drowned the mice, or that caught and kept them alive (a) to be drowned or set free outside later. Others dropped a heavy wooden block to crush them or hung them with a wire noose. The one shown in picture (b) was designed to chop off their heads! The simple spring-type traps showed much less imagination.

One wonders how many long winter evenings were spent dreaming up new ways of trapping the little rodents, or perhaps watching and waiting for them to be trapped. With such variety it is surprising that it was not until 1869 that the first one was patented in the U.S.

(a) Two pieces of tin, the trap door and the teeter totter floor inside, allow the mouse to enter on the right side of the trap, and close the door after. The only escape then is into the larger chamber on the left where the wire loops drop down to keep him a prisoner. The trap would hold several mice. 5¾" wide, 6½" deep, 4½" high.

(b) The long iron blade was positioned under tension above the hole in the wood block. When the mouse responded to the bait inside, the trap was tripped and the mouse lost his head. Probably third quarter 19th century.

(c) If this stringed instrument is a banjo, it is indeed an anomaly. The rattlesnake skin head, the three strings and the unusual spacing of the frets suggest it was homemade. On the other hand, there are parts and workmanship that one would expect to find in an inexpensive factory-made instrument. Overall length 31".

Flutes were perhaps the most common homemade instruments. This attractive one in pine is much easier to view than to play. It is 15" long.

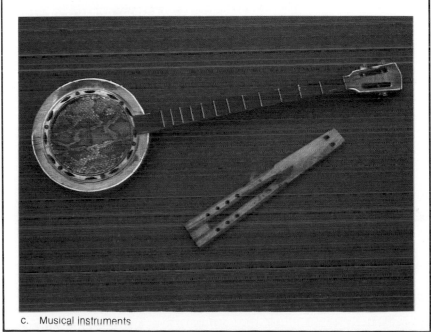

c. Musical instruments

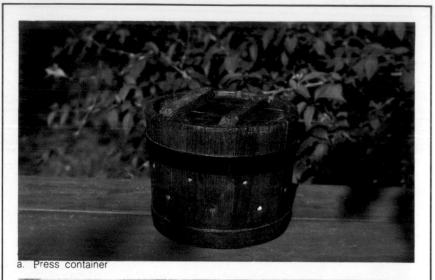

a. Press container

b. Cheese press

c. Pack saddle, prod, poke

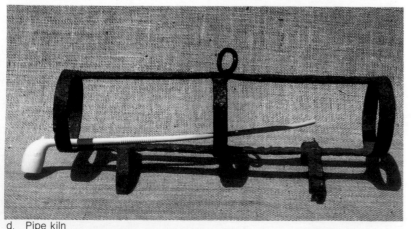

d. Pipe kiln

In addition to the lard press on page 89, presses were made in many shapes and sizes to compress fruit and berries for jelly, cider, fruit juices and wine. There were also sausage presses and cheese presses, and ones for herbs.

(a) The small bucket, 8¼'' diameter at the top and 6½'' high, appears to be a container used in a press. Wood staves are about ¾'' thick and the bottom inset so that it is only about 5'' deep inside. Several holes are drilled 1'' or more above the bottom. This is unusually high for a container used to extract liquids. Unfortunately, refinishing has removed any residue or condition that might have offered some clues.

(b) This exceptionally well-constructed cheese press has an overall height of 48''. It was originally painted red.
One of these presses with two horizontal pieces of wood at the top is on display in the Ford Museum at Dearborn, Michigan. Cheese was pressed in a wooden cylinder that sat on a drainage board.

(c) Pack horses and mules were used to carry loads. The wooden pack saddle with hand-forged loops was originally decorated with brass upholstery nails.

The blacksmith-made animal prod has a flat tube that projects about 1'' beyond the surrounding points. If more prompting was required and additional pressure applied, the animal would "get the point"!

Pioneers visited the woods and forests in search of natural forms that could be adapted to farm and household uses.
Two holes drilled in one piece of wood were all that was required to hold this poke together. This is a device used to prevent cattle or other farm animals from breaking through fences.

(d) Clay pipes were periodically baked in a hot oven to burn off tobacco juices that had penetrated the clay. Pipe kilns were racks that held a few dozen at a time for this purpose. This practice was reported to have been carried out until the mid 1800's in at least one location in England.

Opposite ▷
The pipe box with ivory inlay that includes whales and a narwhal, is an exceptionally fine example of scrimshaw.
Pipe tongs were used to light a pipe with a glowing coal or ember. Both pieces are 18th or early 19th century.

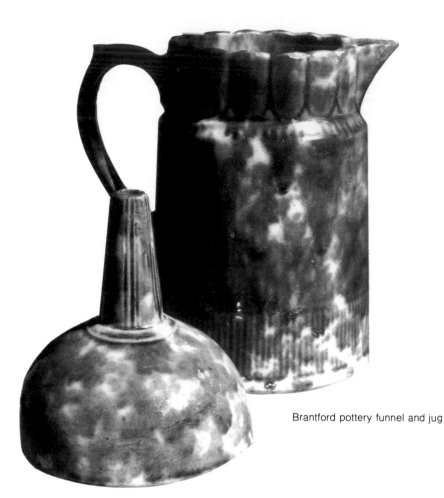

Brantford pottery funnel and jug

b. Bennington-type insulator

Pottery was made from clay, shaped entirely by hand or on a potter's wheel, and then fired. Finely-textured liquid clay, called slip, was poured into plaster of paris molds to make decorative parts or more complex pieces. Slip was also used as a transluscent or opaque coating or to create decorations. A clear or tinted glass-like glaze with a silica base was often used over the base clay or over a slip covered piece.

Stoneware, made of a particular type of light colored clay that is strong and durable, required firing at much higher temperatures. Salt added during the firing produced gases which chemically combined with the silica in the clay to give a transparent hard exterior surface known as salt-glaze. The inner surface of these containers was usually slip glazed.

Pottery with a tortoise-shell or mottled effect is known as Rockingham, and originated in England in the 18th century. A similar type was later made at Bennington, Vermont. Canadian production took place in the last half of the 19th century. Although it is mainly referred to as Rockingham, Bennington or Brantford pottery, it was made by dozens of factories until about 1900.

The warmth and charm of these utilitarian wares make them popular with collectors. Many seek pieces that are signed or attributed to specific factories, or those which are considered rare. This fortunately leaves many attractive examples for those who are only concerned with appearance.

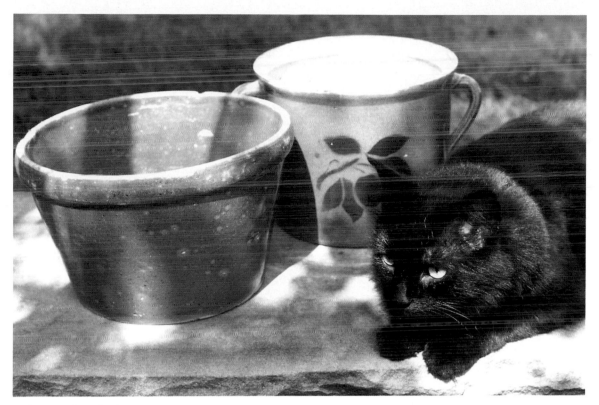

a. Pottery bowls that are unglazed, partially glazed or fully glazed, or ones that are decorated or stencilled are both useful and decorative today. Sam's persistent attempts to be included in a photograph succeeded here.

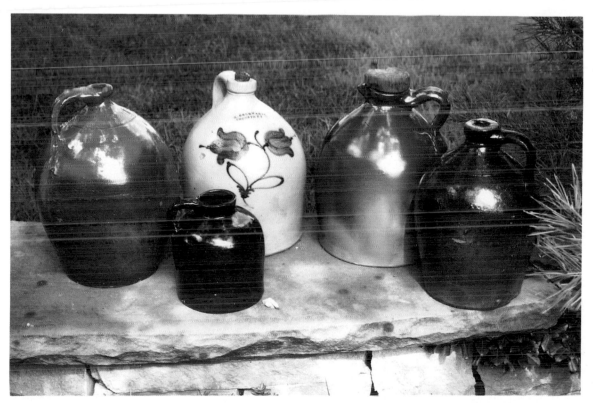

b. Stoneware and redware jugs above, include a variety of glazes and sizes. The salt-glazed stoneware jug with the cobalt tulips is signed N. EBERHARTD TORONTO C.W. This is an error in the spelling of Nicholas Eberhardt, a Toronto potter of the 1860's.

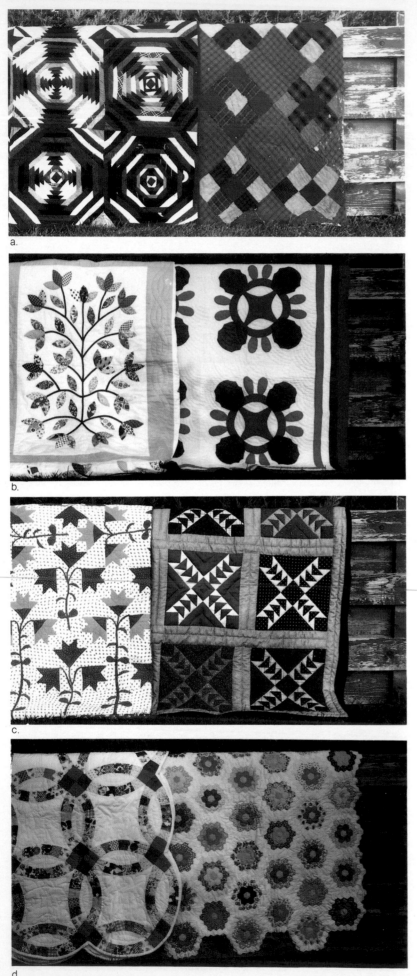

The making of quilts started as a practical necessity and developed into an important social event, which often produced outstanding examples of folk art. Many designs were original while others were traditional. Color, texture and regional variations gave originality to common patterns. Different names were often assigned to the same patterns in widely separated areas, and those used here are ones given to these quilts in Ontario.

(a) Left: Log Cabin or Pineapple design.
 Right: Quilted homespun materials; no pattern name.
(b) Left: Tree of Life.
 Right: Bold geometric design; no pattern name.
(c) Left: Lily of the Field.
 Right: Flying Geese.
(d) Left: Double Wedding Ring
 Right: Grandma's Flower Garden

With the evolution of machinery in the textile industry, the necessity of the laborious effort required for quiltmaking diminished. In recognition of this effort, quilts were often put away to be brought out as show pieces. For this reason, some quilts made many years ago have a new appearance. An interesting, well-made quilt of any age is always appreciated.

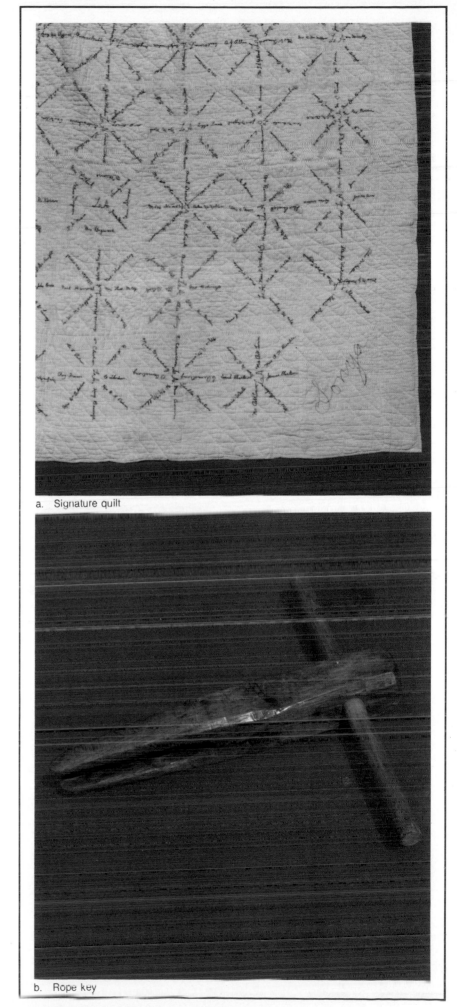

a. Signature quilt

(a) The signature quilt is a type of friendship quilt that was made in individual block units by a number of women. A quilting bee was organized, usually by those responsible for the idea, and on this occasion the separate parts were assembled and sewn onto a backing. An inner lining of wool or cotton was used, and the work done on a quilting frame.

A party would follow, with perhaps the men attending, and the completed work was then presented. The recipient would likely have been an esteemed person or a bride. This signature quilt is from Sonya, a hamlet in Ontario.

(b) Mattresses were supported on ropes strung on a bed frame. A rope key is a tool used to tighten the ropes.

b. Rope key

a. Early in the last century, hooked rugs were made from old clothing. The fabric was cut up into strips and pulled through a strong linen or hemp sacking background. Geometric patterns such as this were simple to design and execute.

b. In the last half of the century, stencilled designs on burlap became available. This greatly limited the number of original designs produced. The above rug is made of long strips of fabric cut to achieve a deep pile.

a. The delightfully distorted perspective exhibits an exuberant release of naive creative instincts. Pictorial and illustrative rugs are frequently mounted on a frame to be hung on a wall.

b. Most appliqué rugs are made with geometric designs, and the "coin spot" is one of the most popular. Many exhibit interesting color combinations, utilizing scraps of material, often pieces of wool suiting. Burlap is the usual backing, but I have seen one sewn on a pair of worn overalls.

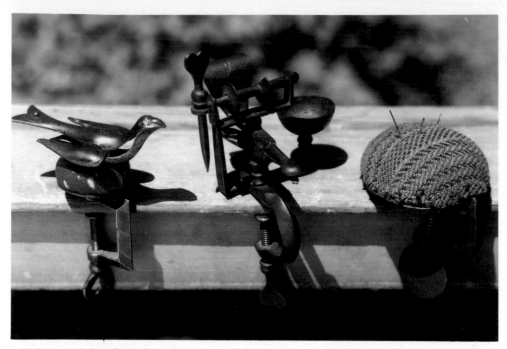

a. It is surprising there is not a currently popular counterpart for the sewing bird. They were also called embroidery or netting table vises. Embroidering and netting are not popular pastimes today, but such a clamp would be very useful for routine hemming. Pressure on the bird's tail opens its mouth which serves as a clamp. In addition to the clamp, the center workholder has a bodkin for piercing holes in fabric or leather, a spool holder, and originally it had a tiny pincushion in the cup. On the right is a combination clamp and pincushion.

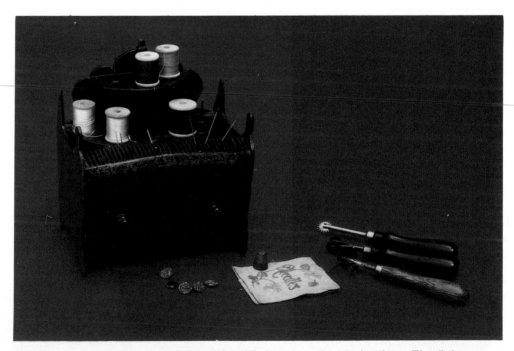

b. Cigar boxes provided the wood for this homemade sewing box. The little drawer knobs have been whittled, and blunted nails hold the spools. Shown also are old buttons, a thimble, an embroidered needlecase and fixed and adjustable tracing wheels. These were used to transfer patterns, often included as magazine supplements, onto large sheets of paper. Many have left their pinpoint tracks across kitchen tables.

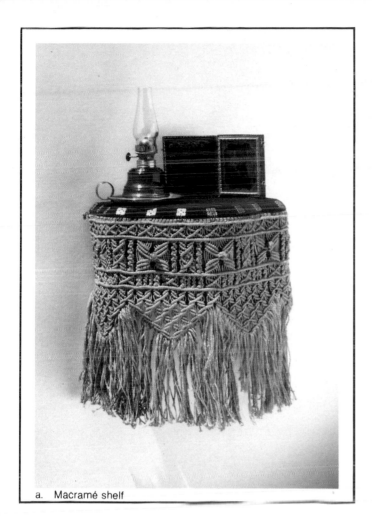

a. Macramé shelf

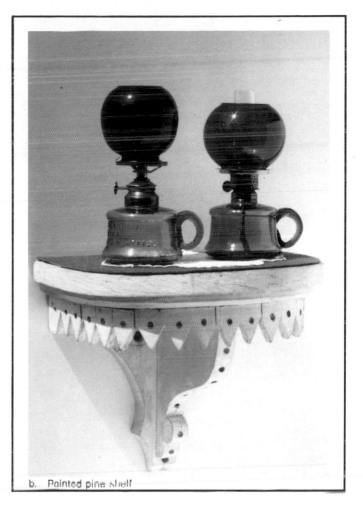

b. Painted pine shelf

Tho decorative shelves illustrated were the work of men and women in the last half of the 19th century.

(a) Macramé, red velvet and gold ornaments were combined to make a typically late Victorian shelf. The saucer night lamp was patented in 1873, and the tintype is framed in a typical display case. The shelf is 11'' wide, 7½'' deep and 12'' high.

(b) This shelf, 10'' high and 11'' wide, was possibly made for a church. It holds night lamps that were manufactured in the last quarter of the 19th century.

(c) The carved walnut shelf has rather crude chiselled designs. Flower stands or ivy stands as they were also described, were advertised by Bradley & Hubbard of West Meriden, Conn. in the 1880's. This one closely resembles the catalogue illustration. The shelf is 18'' wide and 9½'' high.

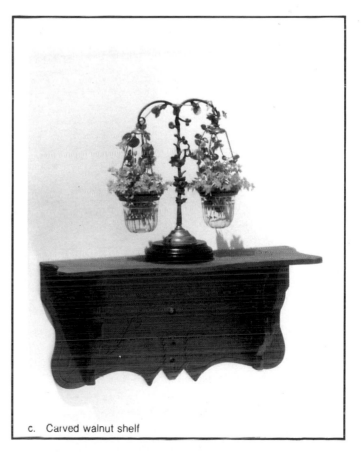

c. Carved walnut shelf

a. Shoehorns

b. Shoe lasts

c. Spigot and spile

(a) These shoehorns are made of the material from whence they received their name. Horn is a pliable material that can be heated, shaped and carved.

(b) This group of crudely-made shoe lasts could have been used for a growing family. The built-up leather would add a year or two to the wooden last.
In some areas, an itinerant shoemaker would go into the homes and make shoes for the entire family.

(c) The spigot, made of walnut and cherry, was drilled and then hand carved.
Spiles are spouts inserted into holes drilled in maple trees to direct the sap into a bucket below. After they were whittled and grooved, a hole was burned through the solid end with a hot wire.

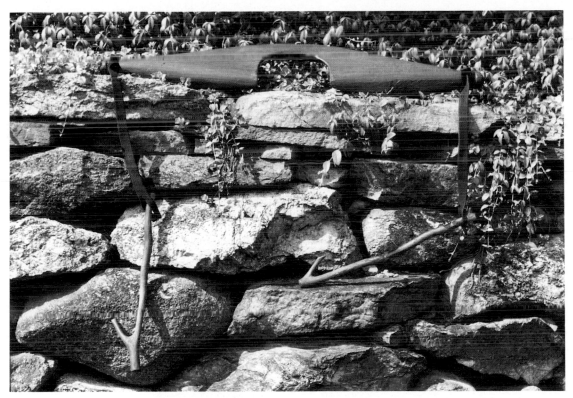

a. Shoulder yokes were used to carry two pails at a time. Hooks were made from natural forms or forged iron.

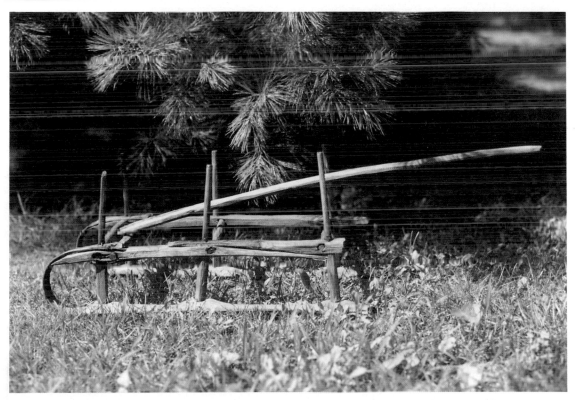

b. Logging sleds carried a supply of cut logs home for the fire. This one, about 3' long, was made for a child.

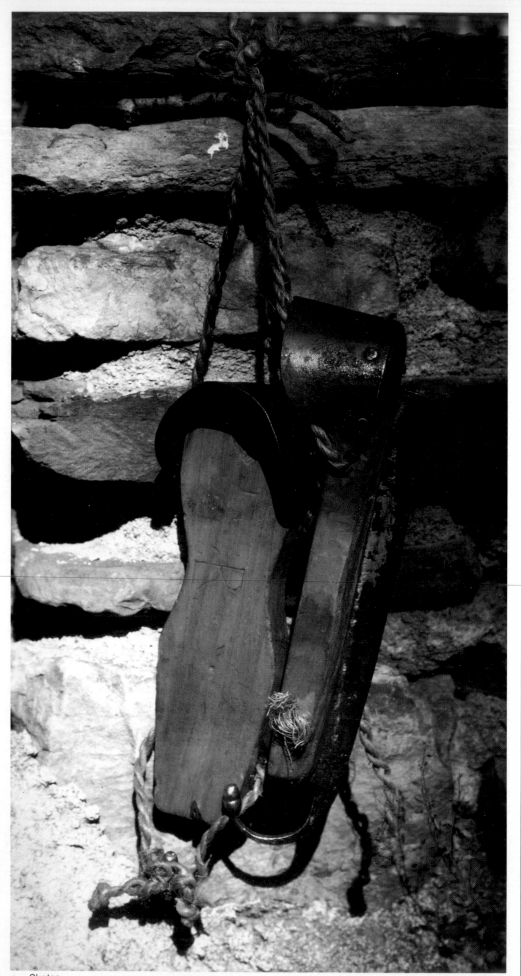

a. Skates

In the United States there were about 200 ice-skate patents issued in the third quarter of the 19th century. Although this may suggest that skates were largely factory produced during the last half of the century, many were probably handmade in remote areas.

This attractive pair, with forged iron parts and brass acorn finials, has L and R carved on the soles. The skates are identical in shape, and therefore interchangeable, so the reason they were marked probably had something to do with the wear or sharpening of the blade.

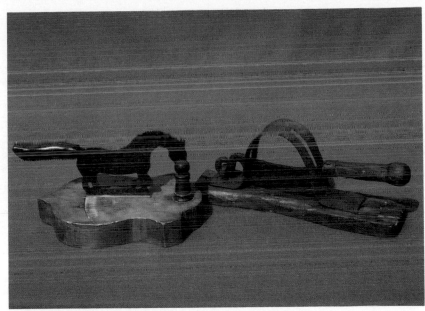

a. Tobacco cutters

b. Cutter, side view

(a) The tobacco cutter on the left is a type that was used to finely cut tobacco leaves for smoking tobacco. It also very effectively chops vegetables, and could have many other applications. They were often made in decorative shapes, and the horse was a popular motif. The overall length is 11½'' and the height is 6½''.

In the last half of the 19th century, all-metal tobacco cutters with a fixed blade and a base plate marked off in inches, were used in stores to cut a measured amount off a large block. The large blocks were also sold for home use, and a cutter such as the one on the right could have been used at home to cut off smaller pieces. This was made by a blacksmith who used a rasp for the blade. It is 14'' long and 6'' high.

(b) and (c) I have seen three of these cutters, and have heard of many others. All have been called tobacco cutters, and all have been handmade ones from Quebec. They very closely resemble straw or feed cutters that are two or three times larger. As the knife is raised, the three paddles attached to the horizontal bar, are projected through the bottom of the trough. This would push whatever is in the trough forward about 1/8''. There is a gummy residue around the knife, and a chemical analysis might indicate prior use. The length is 18'' and it is 17'' high.

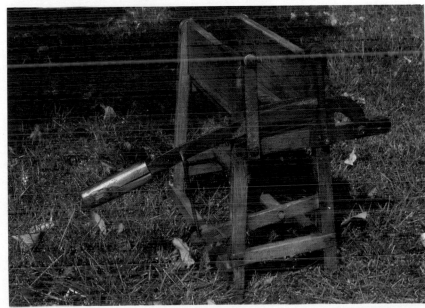

c. Cutter, end view

a. Towel racks, like shelves, were often made by craftsmen at home. The hand-carved example above is circa 1900.

b. It is fortunate that this unusual 18th century towel rack retains its original paint.

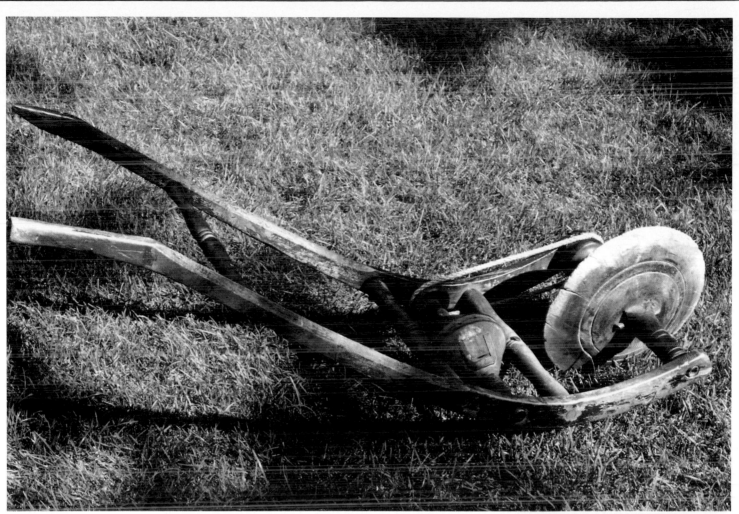

a. Seed drill

My interest in collecting began with tools, perhaps because I had taken courses in woodcarving and furniture making. One can readily appreciate the remarkable precision of the beautiful tools that were factory made of exotic woods such as mahogany, rosewood and ebony, however, one can more easily sense the close relationship of the craftsman with his tools, if he made them himself.

Tools have been collected and researched for over half a century, but since the supply of many types is so great, it is not difficult or expensive to assemble a small collection. They will be better enjoyed and more meaningful if you study and understand their use, and if you try using them.

The tools pictured here are ones that are obviously homemade or blacksmith made.

(a) Hand-forged nails are used in this seed drill from the Maritimes. As the front wheel makes a furrow, the pulley rotates the tin hopper to drop seeds. Two dowels in the crosspiece above the hopper have been broken off underneath. These were possibly part of an arrangement to cover the seeds with earth. 54" long.

(b) This garden-row marker or reel is essentially the same as the plastic ones made today. The marker was driven into the earth at one end of the row, and the twine attached to a spike was played out and pegged in at the other end of the row. Hand forged, probably before 1850. 29" high.

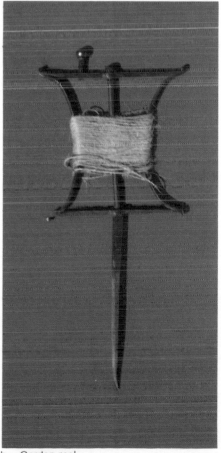

b. Garden reel

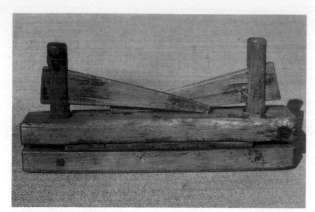

a. Bookbinder's press

b. Cooper's saw croze

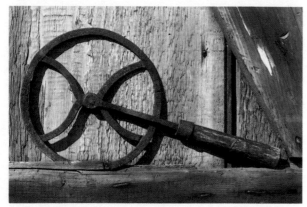

c. Traveler

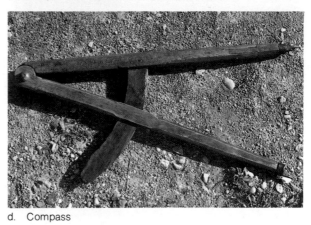

d. Compass

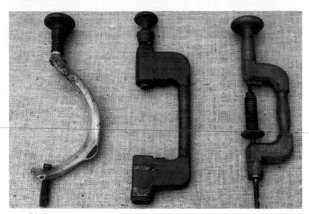

e. Bit braces

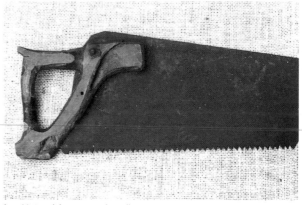

f. Natural form saw handle

All tools on this page are 19th century or earlier.
(a) This is a bookbinder's press that held small books for stitching. 13" wide, 6½" high.

(b) Coopers used a croze to cut a groove inside a barrel to fit the head. Although handmade ones are often seen, this one has the added interest of a pattern and initials inscribed on the surface. This saw croze is 15" long.

(c) Blacksmiths used a traveler to measure a wheel for an iron tire, by counting the number of rotations required to circumscribe the perimeter.

(d) Wheelwrights, millwrights and coopers were some of the tradesmen who would use a large compass. This one has a design along the arms that was stamped with a tool. One point has an old repair.

(e) Another example of a natural form is the exceptional bit brace on the left made from an antler. The 18th century one in the center has been reinforced by filling a prepared groove or cavity with a soft metal.
On the right, a spool has been fitted into the frame of the bit brace to convert it into a bow drill.

(f) This saw handle is such an excellent natural form that it almost appears to have been grafted for this purpose.

This group of 19th century farm tools was chosen for their handmade characteristics. They are described from left to right.

1. The blacksmith-made weeding iron was used to extract weeds, particularly thistles, from the earth.

2. Also made by a blacksmith, was this cant hook fastened to a branch. Missing is an additional iron ring that held the iron plate to the wood at the top. Logs were turned or rolled with this tool.

3. An entirely hand-forged rake has been attached to a handle made from a wagon shaft that retains some of its original paint.

4. A flail was used for threshing, that is, separating seeds from the stalk. The grain or corn was spread out on the barn floor and beaten with the shorter pole that was swung over the shoulder.

5. Flat wooden shovels were used for snow. Scoop-shaped shovels were for grain.

6. One prong of this fork has been replaced. Repairs that were done to prolong the life of a tool can add interest. A design has been incised along the handle and the older outside prong.

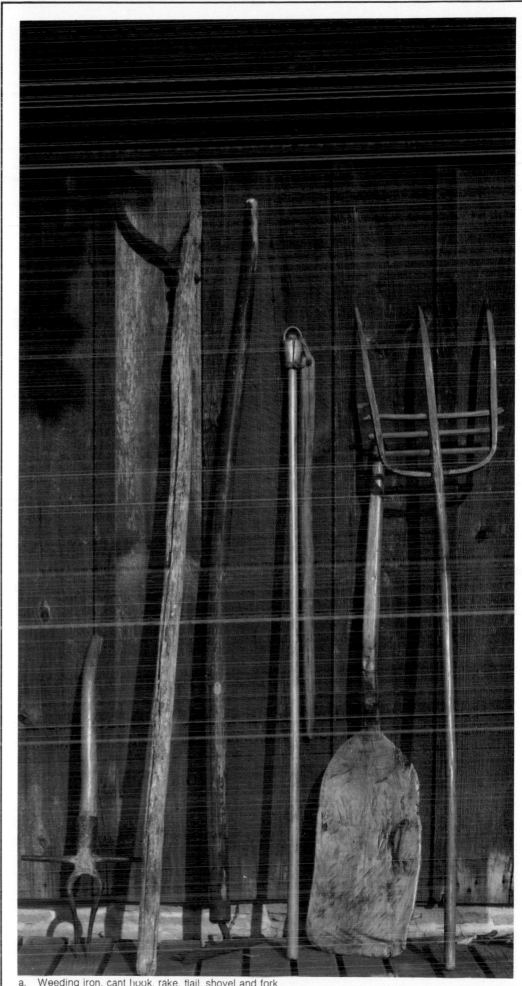

a. Weeding iron, cant hook, rake, flail, shovel and fork

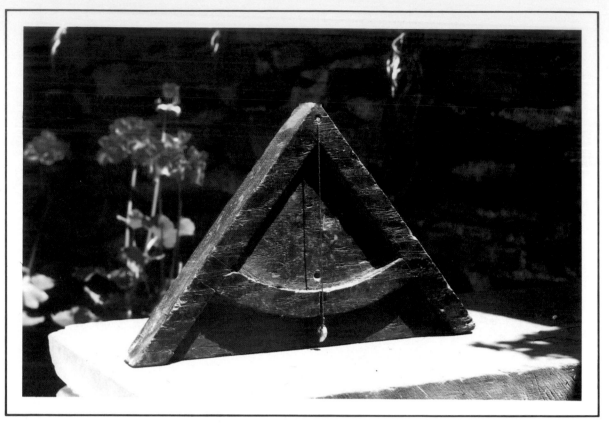

a. An A-level is a simple ancient tool. When placed on a level surface, the plumb line coincides with a vertical groove marked in the cross arm. Carved from one piece of oak, it measures 9'' at the base.

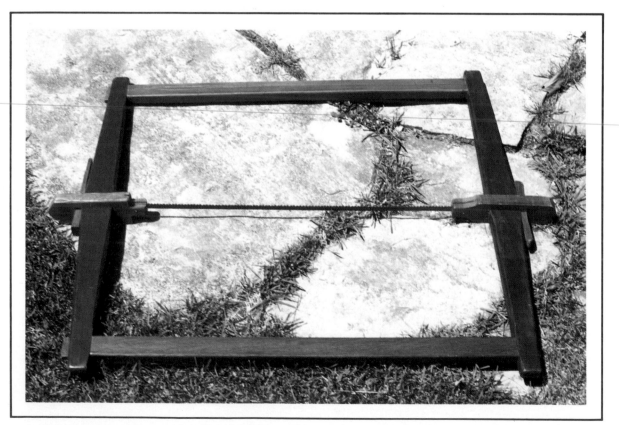

b. Frame saws were used by wheelwrights, cabinetmakers and others to saw curved parts. The side bars, often badly worn from use, may have been replaced here. They are of two different woods, and the projecting tenons are not in keeping with the chamfered cherry ends. 31'' long.

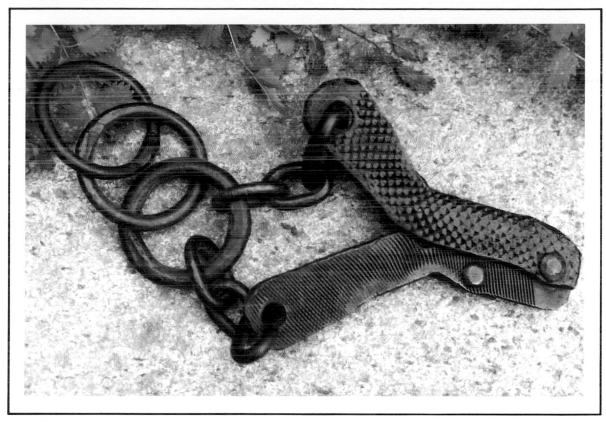

a. Files and rasps were made with high quality steel. They could not be sharpened when worn, and were therefore recycled to make other tools. This rugged part of a fence-wire tightener or stretcher, gripped the wire (on the other side) as it was tightened with a block and tackle.

b. Oilstones, like the one in the round wooden case, are used to sharpen chisels, knives and other sharp-edged tools. Whetstone holders, hooked over the belt, were taken into the fields, and then poked into the earth so the stone could be handy for sharpening scythes and sickles.

a. Conestoga wagon jack

b. Hand-forged carriage jack

(a) This type of wagon jack, often referred to as a Conestoga wagon jack, dates back to the 17th century. This one is signed ORDNER 1826. All the metal parts including the mechanism are hand forged.

(b) From a design standpoint, most wagon or carriage jacks have interesting shapes. This hand-forged one surpasses all that I have seen. The form, line and sensitive variations of the loops are a delight to the eye. Probably 18th century. 30" high.

c. Carriage jack

(c) The red paint emphasizes the simple bold shape of this late-19th century carriage jack. While the Conestoga wagon jacks are similar in design, other types vary widely, and although there were many mass-produced ones, it is not difficult to find a homemade one.

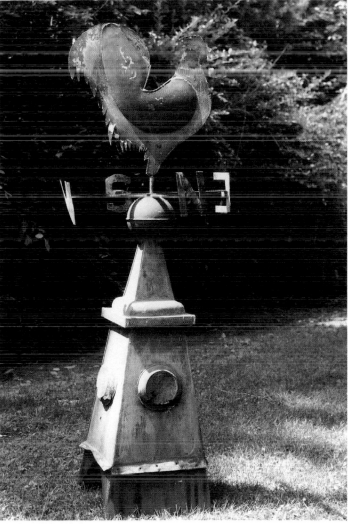

(a) Weathervanes have a history that dates to 100 B.C. The weathercock or chanticleer weathervane came into use a thousand years ago, as a religious symbol of the Roman Catholic church. Bringing their traditions with them, the colonists adopted the rooster as a symbol of Christendom. This most popular motif for weathervanes was created in a variety of forms and materials. Later, objects such as animals and fish, or occupations of tradesmen took the place of the rooster. Many weathervanes have been reproduced, but the one pictured is an old handmade, painted sheet metal one from Bar Harbour, Maine.

(b) This twice-mended trough is a type that was used for soaking meat in brine before it was smoked. It could have been used for various other purposes.

a. Weathervane

b. Wooden trough

a. Flax brake

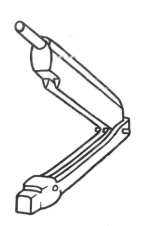

b. Open flax brake showing blades

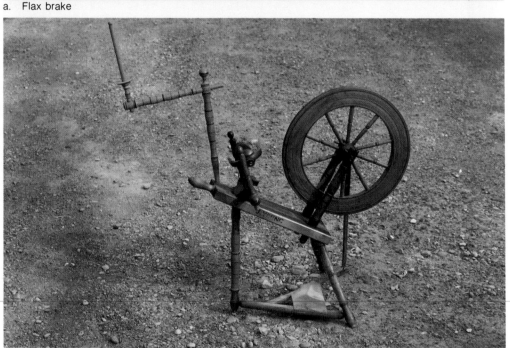

c. Spinning wheel

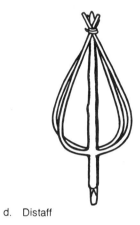

d. Distaff

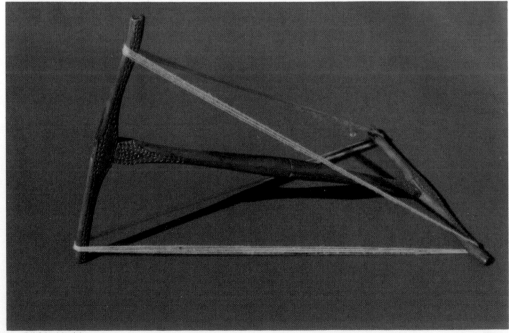

e. Niddy Noddy

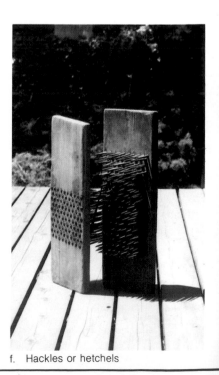

f. Hackles or hetchels

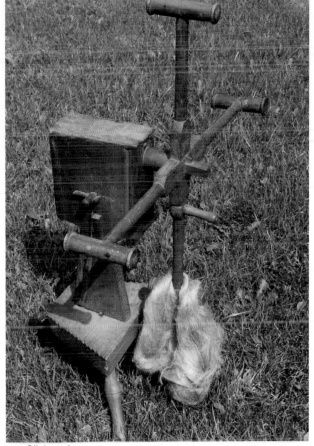

g. Click reel

Flax (Linum) was grown to make linen. After it was gathered, it was soaked in a brook or pond, dried and laid across a flax brake (a) and (b) to be beaten and broken to facilitate the removal of waste material. This 48" initialled model (a) is an exceptionally fine example. Most flax brakes are mounted on a base.

After the flax was taken from the brake, it was tapped and stroked with a scutching knife (page 118) over the vertical end of a board. This removed waste particles and some of the short fibers called tow. From there it was drawn through a set of hackles or hetchels (f) to further remove waste material, and to straighten and separate the short, most desirable fibers, from the long fibers used for coarse thread or rope. The two hackles, about 24" long, show both the long hand-forged spikes on the top, and the faceted heads on the bottom. Some have a wooden box cover.

Historical associations as well as an interesting shape would account for the spinning wheel's popularity among collectors and decorators. This one signed A. YOUNG (c) was made around 1850. The extended arm would have a distaff (d) to hold the unspun fibers.

Yarn was taken from the spindle and wound around a reel to measure a skein. This could also be done on a niddy noddy (e) with rhythmical twisting and turning motions, counting the turns until the required amount was wound. The end of one arm is shaped to easily remove the skein. Chip carving decorates this niddy noddy that is approximately 18" long.

A clock or a click reel (g) counted the revolutions to measure the yarn. Clock reels indicated the measure by a hand on a dial, and the click reel just made a sound after a number of revolutions. The yarn could then be washed or dyed, or it could be put directly onto the barrel-cage or squirrel-cage swift (h). Other swift designs vary considerably. From the swift the yarn was played out onto a bobbin winder.

The brake, hackle and distaff were used for flax. All other pieces could be used for wool, cotton or flax.

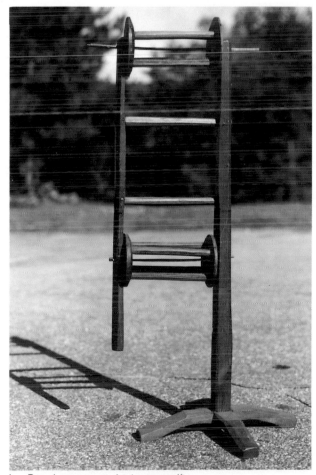

h. Barrel-cage or squirrel-cage swift

a. Narrow pieces of cloth were woven on a tape loom like that shown above. Early 19th century, it is 31½'' long and 11¾'' wide.

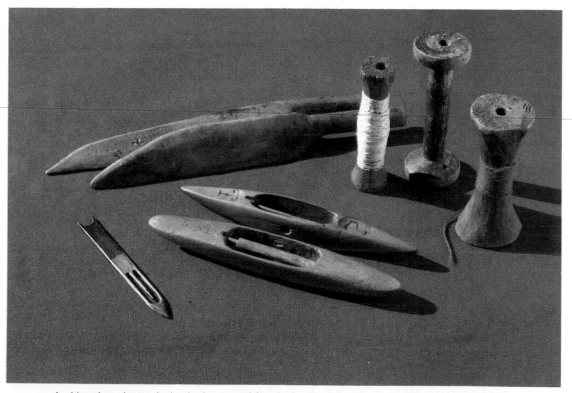

b. Handmade tools include scutching knives, described on the previous page, bobbins and boat shuttles. The small piece with red paint was used for mending fish nets.

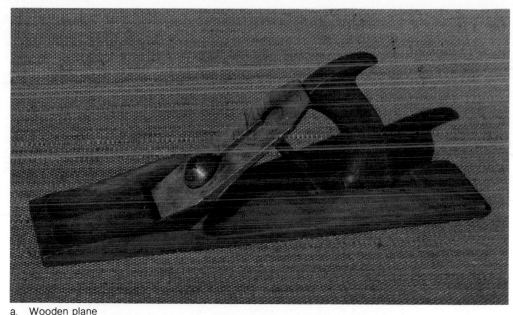

a. Wooden plane

Although all examples shown here are made of wood, whimseys could be made of any material. They were simply made as a pastime to entertain, amuse or to exhibit one's skills.

(a) Fine craftsmanship is evident in this plane made entirely of wood — including the blade! 13½" long and 5" high.

(b) A ball enclosed in a cage was a favorite with wood carvers, but one that pivots on the points of two cones was a real test of skill. 10" to the end of the link.

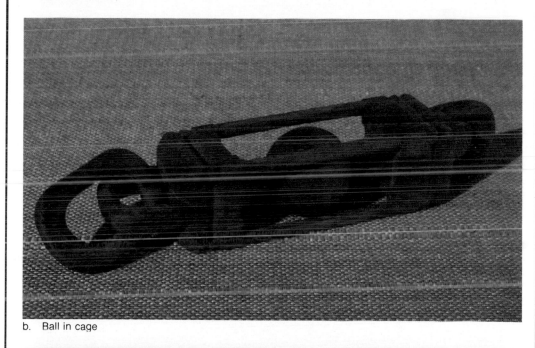

b. Ball in cage

(c) This exceedingly-light miniature grain cradle has a long handle or snath. Overall length is 10".

Full-size grain cradles were also made with shorter handles or bow-shaped ones. Eric Sloane in his book The Seasons of America Past, describes them as "The Stradivarius of early American farm implements". I would agree completely, having a full-size one that was one of my first tool purchases, mounted in a niche in our kitchen.

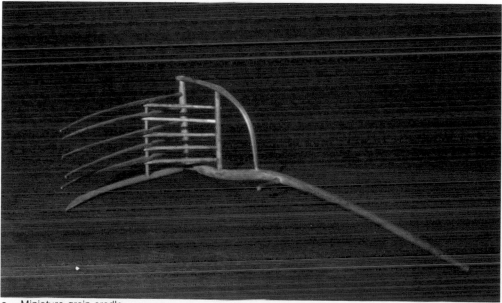

c. Miniature grain cradle

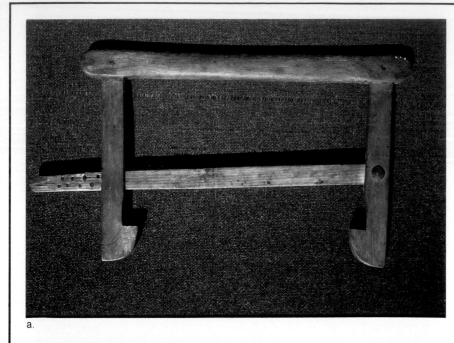

a.

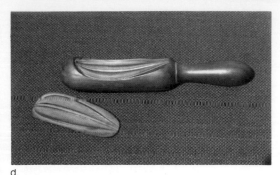

d.

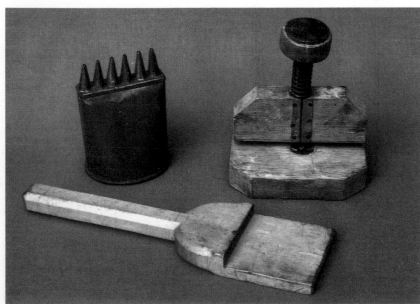

b.

c.

If the purpose of an article is in doubt, it is often referred to as a "whatsit". Some whatsits are unique, having been one individual's solution to a problem, and others may have been a common solution to a problem that no longer exists. A portion of their function is usually apparent, but they really remain a whatsit until they are fully explained and properly named.

The greater the experience one has had in the field of antiques, the fewer whatsits one will encounter, but it is surprising how many unfamiliar objects surface to puzzle the experts. The articles shown here have thus far defied identification by books or by consultation with several experts, but they may strike a familiar note with some readers either through past experience, or by deduction.

Reasonable theories have been suggested, but they are not mentioned here because they have not been verified, and might only misdirect the reader.

The whatsits on this page ▷ are described opposite.

Whatsits

(a) This handle was secured to something by inserting one or two pegs in the holes of the lateral crossbar. The notched verticals will fit under the ears of some crocks, but the crocks could not have had a projecting lid. There is an indication of considerable wear about the crossbar; however the use has not resulted in wear marks from either the strain of a heavy load, or a hand grip.
The top bar is 16" long.

(b) Exceptionally well-constructed tiger maple reel is supported in a cherry frame. Between the wheels, and set in 1½" from the frame perimeter, are bars of wood ½" wide x 1-13/16" long x 1/8" thick. These very hard pieces of wood have coarse diagonal saw marks on both sides. The design and construction suggest it was made in the last half of the 19th century. Overall height is 13½".

The 15¾" knife in fig. (b) is similar to many rather dull, wide-blade wooden knives that have been ascribed to either Pennsylvania or Europe. Crude but bold in both design and workmanship, this piece is enhanced by the repaired handle that has been pegged and wired.

(c) A 6" tin funnel tapers to holes about 3/32" in diameter. It would not be possible to control the rate of flow, nor could it be used as a mold because of the construction of the interior.

To push or hold something in place was the reason for the paddle-like object with the carefully chamfered edges, shown at the bottom of fig. (c) It is 13½" long and came from an early 19th century farm.

Also in fig. (c), is an interesting triangular punch. Made from a file, it moves through a tin sleeve that is secured by nails. A 1 cent Canadian Queen Victoria piece is used as the die. It reads 190__, but unfortunately the last number of the date is cut out. When operated, a sharp angle at the base of the punch cuts on two edges but not on the third, thus leaving an angled V pushed through the material punched. It takes a good deal of pressure to compress the strong spring which would account for the leather pad on the handle. It is 7" high, and the principal wood is oak.

(d) This item appears to be a carefully crafted mold made in the shape of a leaf. The clearance between the two parts indicates that a thin material was molded, and the absence of any clamp might mean that little pressure was required. The mold is made of a fine-grained hardwood having a duller finish on the outside of the smaller portion. Both pieces have a gray-green coloration in the recessed areas. As with all what's its, one cannot be sure if every wear mark or color or clue, is relevant to the original use. The overall length is 7", and the diameter 1½".

A Collector's Notebook

Many months have elapsed and many miles were travelled in the preparation of this book. During that time I jotted down some thoughts and ideas related to the book and to collecting. Recorded here are some that may be of interest to both the novice and the serious collector.

Availability and Value
of Primitives & Folk Art

With only four or five exceptions of relatively common items, all articles included in the book were for sale, or in private collections, and will probably be in circulation in the future. Many of the articles included are easy to find; and many are not. If they were all common and readily available, one of the main joys of collecting would not exist. This is the joy of discovering something special that has not been recognized by others.

Because of the individual nature of handmade articles, and without recognition in many areas, of their rare, exceptional or artistic value, it is still possible to find important pieces at reasonable prices.

There isn't a formula for every article that can combine demand, rarity and price. Rarity sometimes has little relationship with demand or price, and a great demand for articles that exist in large numbers will affect their availability. Most collectors who have had a long search for a particular piece have experienced the surprising coincidence of having two turn up at almost the same time.

It is impossible to predict availability accurately; there are too many variable and unknown factors. It should also be kept in mind that for some pieces the difference in price between the ordinary and the exceptional is slight, and with others it is very great.

Many primitives and folk art pieces have been lost through neglect or destruction, because they were considered worthless. In the past few decades a substantial market value has resulted in the preservation of these artifacts. Handmade articles have the advantage of being more difficult to reproduce in large quantities. Individual expensive pieces unfortunately have the potential disadvantage of being so skillfully duplicated that the reproduction is difficult to detect.

The Marketplace

There are four areas to search for primitives and folk art. They are antique shops, shows including flea markets, auction sales and advertisements found in magazines and newspapers. If a specific item is sought, one should give the details to a number of dealers to increase the chance of finding it. A stamped self-addressed post card or envelope, left with the pertinent information, will serve as a remindor.

Antique shows and flea markets offer the opportunity to examine a great number of articles at one time. At shows, most dealers relegate their primitives to the floor beneath their tables. If these are the object of your search, you must be prepared to view the show from a crouched position with the risk of being stepped upon or tripped over. Attending auction sales can be time consuming, but it can also be very entertaining.

Catalogued sales allow you to make a telephone or write-in bid, however there is always an element of risk regarding the accuracy or completeness of the description. This also applies to advertisements. Magazines and newspapers allow you to do some armchair shopping. Unfortunately, the fact that only a small percentage of the illustrations include prices, makes inquiries expensive.

Decoration

The rarest, the most expensive and the most sought after, are not necessarily the most decorative items. Antique shops, shows and auctions abound with inexpensive pieces that can be displayed in an imaginative setting, or which can become part of an attractive grouping.

There is great scope for large antiques to be used in spacious areas of public or commercial buildings. They should of course, be protected from damage that might occur from strong light, too much or too little cleaning, and vandalism.

Cleaning, refinishing or restoring folk art and primitives should be approached with caution. That which is done cannot be undone!

Artifacts should remain in "as found" condition until every aspect of any proposed alteration is considered. If there is any possibility that the piece is destined to a museum or restoration it should be left untouched. Otherwise, a minimum of alteration is advisable, and expert advice should be sought to insure that any change will be an improvement. Most museums and restorations have personnel qualified to give direction in this area.

Quality and Design

If something is truly representative of a place and time, it may not have good design qualities, but if it is an honest expression, it often has a special charm. This is the appeal of many primitives.

In some categories, handmade primitives were executed with little variation from a basic common design, while in other categories such as apple peelers, mousetraps and cressets, their makers expressed vastly different interpretations showing much greater creativity and individuality.

The difference between the ordinary and the exceptional is often very slight, not only in terms of price as stated earlier, but also in terms of quality. Sometimes it is the imperfections that are part of the originality of a piece that make it exceptional. Other times it is merely a subtle variation in the elements of design.

Collectors

Serious collectors must be prepared to research with an inquisitive and suspicious mind. Everything in books, museums and restorations, as well as in other collections or offered for sale, should be questioned. Ask yourself —

What is it?

Why is it here?

Does it conform to its stated purpose?

Is it an anachronism?

Keep in mind that many articles had multiple uses; even those which were designed for one purpose and expected to be used for that alone. Surprise and sometimes disappointment will occur with this approach.

Many mistakes have been made, and should be forgiven. It can be the role of the collector-researcher to contribute to the constantly improving presentation of our heritage.

Photography

All photographs were taken outdoors with an Asahi Pentax camera, model K2 with an SMC Pentax 1:1.8/55 mm lens.

The naturalness of sunlight seems to be in greater harmony with our handmade heritage, than the sophisticated, controlled-shadow treatment of the studio.

Bibliography

Abrahamson, Una. GOD BLESS OUR HOME, DOMESTIC LIFE IN NINETEENTH CENTURY CANADA. Toronto: Burns & MacEachern Limited, 1966.

Adamson, Anthony & John Willard. THE GAIETY OF GABLES, ONTARIO'S ARCHITECTURAL FOLK ART. Toronto: McClelland and Stewart Limited, 1974.

ANNUAL OF ARTICLES ON ANTIQUES, VOL. I TO VOL. VI. Dubuque, Iowa: The Antique Trader Weekly, 1972-1977.

Berney, Esther S. A COLLECTOR'S GUIDE TO PRESSING IRONS. New York: Crown Publishers, Inc., 1977.

Bishop, Robert and Elizabeth Safanda. A GALLERY OF AMISH QUILTS. New York: E. P. Dutton & Co., Inc., 1976.

Blandford, Percy W. COUNTRY CRAFT TOOLS. New York: Funk & Wagnalls, 1976.

Burnham, Harold B. and Dorothy K. KEEP ME WARM ONE NIGHT, EARLY HANDWEAVING IN EASTERN CANADA. Toronto: University of Toronto Press, 1972.

Channing, Marion L. THE TEXTILE TOOLS OF COLONIAL HOMES FROM RAW MATERIALS TO FINISHED GARMENTS BEFORE MASS PRODUCTION IN THE FACTORIES. Marion, Massachusetts: The Channings, 1969.

THE COMPLEAT FARMER, A COMPENDIUM OF DO-IT-YOURSELF TRIED AND TRUE PRACTICES FOR THE FARM, GARDEN & HOUSEHOLD. New York: Main Street/Universe Books, 1975.

Cooke, Lawrence S, ed. LIGHTING IN AMERICA, FROM COLONIAL RUSHLIGHTS TO VICTORIAN CHANDELIERS. New York: Main Street/Universe Books, 1975.

Darbee, Herbert C. GLOSSARY OF OLD LAMPS AND LIGHTING DEVICES. Nashville, Tennessee: American Association for State and Local History Technical Leaflet 30. History News Vol. 20, No. 8, August, 1965.

de Jong, Eric, ed. COUNTRY THINGS, FROM THE PAGES OF THE MAGAZINE, ANTIQUES. Princeton: The Pyne Press, 1973.

Dickason, Olive Patricia. INDIAN ARTS IN CANADA. Ottawa: Department of Indian Affairs and Northern Development, 1972.

Di Noto, Andrea, ed. THE ENCYCLOPEDIA OF COLLECTIBLES. Alexandria, Virginia: Time-Life Books, 1978.

Eaton, Arthur Westworth Hamilton. THE HISTORY OF KINGS COUNTY. Salem, Massachusets: The Salem Press Company, 1910. Facsimile edition by Mika Studio, Belleville, Ontario, 1972.

Edgell, George Harold. THE BEE HUNTER. Cambridge, Massachusets: Harvard University Press, 1949.

ENCYCLOPEDIA BRITANNICA, 11th Edition. New York: Encyclopedia Britannica Company, 1910.

Flayderman, E. Norman. SCRIMSHAW AND SCRIMSHANDERS, WHALES AND WHALEMEN. New Milford, Conn.: N. Flayderman & Co., Inc., 1972.

Franklin, Linda Campbell. AMERICA IN THE KITCHEN, FROM HEARTH TO COOKSTOVE, AN AMERICAN DOMESTIC HISTORY OF GADGETS AND UTENSILS MADE OR USED IN AMERICA FROM 1790 TO 1930. Florence, Alabama: House of Collectibles, 1974, and Rev. 1976.

Freeman, Larry. CAVALCADE OF TOYS. New York: Century House, 1942.

Glissman, A. H. THE EVOLUTION OF THE SAD-IRON. Carlsbad, California: A. H. Glissman, 1970.

Gordon, Lesley. PEEPSHOW INTO PARADISE, A HISTORY OF CHILDREN'S TOYS. London: George G. Harrap & Co. Ltd., 1953.

THE GREAT EXHIBITION LONDON 1851, THE ART-JOURNAL ILLUSTRATED CATALOGUE OF THE INDUSTRIES OF ALL NATIONS. New York. Bounty Books, a Division of Crown Publishers, Inc., 1970.

Gould, Mary Earle. ANTIQUE TIN AND TOLE WARE. Rutland, Vermont: Charles E. Tuttle Co., Inc., 1958. Second Printing 1967.

_____. EARLY AMERICAN WOODEN WARE & OTHER KITCHEN UTENSILS. Rutland, Vermont: Charles E. Tuttle Co., Inc., 1942. Rev. Edition, 1962.

Hayward, Arthur H. COLONIAL LIGHTING. Boston: B. J. Brimm Co., 1923.

_____. COLONIAL LIGHTING. THIRD ENLARGED EDITION WITH A NEW INTRODUCTION AND SUPPLEMENT, "COLONIAL CHANDELIERS" BY JAMES R. MARSH. New York: Dover Publications, Inc., 1962.

Hornung, Clarence P. TREASURY OF AMERICAN DESIGN, TWO VOLUMES IN ONE. New York: Harry N. Abrams, Inc.

Israel, Fred L., ed. 1897 SEARS ROEBUCK CATALOGUE. New York: Chelsea House Publishers, 1968.

Johnson, Lawrence A. "FRUIT LIFTERS", THE CRONICLE, Early American Industries, Vol. 10, No. 3. September, 1957. 28-30.

Kauffman, Henry J. EARLY AMERICAN IRONWARE CAST AND WROUGHT. Rutland, Vermont: Charles E. Tuttle Co., Inc., 1966.
_____. PENNSYLVANIA, DUTCH AMERICAN FOLK ART. New York: Dover Publications, 1964.

Kebabian, Paul B. and Dudley Witney. AMERICAN WOODWORKING TOOLS. Boston: New York Graphic Society, 1978.

Ketchum, William C. Jr., AMERICAN BASKETRY AND WOODENWARE. New York: Macmillan Publishing Co., Inc., 1974.

Kilby, Kenneth. THE COOPER AND HIS TRADE. London: John Barker (Publishers) Ltd., 1971.

Kovel, Ralph and Terry. AMERICAN COUNTRY FURNITURE 1780-1875. New York: Crown Publishers Inc., 1965. Third Printing 1967.

Lantz, Louise K. OLD AMERICAN KITCHENWARE 1725-1925. Camden, New York: Thomas Nelson Inc. and Hanover, Pennsylvania: Everybody's Press, 1971.

Layton, Dudley A. LET'S COLLECT OLD WOODWORKING TOOLS. Norwich: Jarrold Colour Publications, 1977.

Leggett, M. D., comp. SUBJECT-MATTER INDEX OF PATENTS FOR INVENTIONS ISSUED BY THE UNITED STATES PATENT OFFICE FROM 1790 TO 1873 INCLUSIVE. Washington: Government Printing Office, 1874. Three Volumes, Reprint Edition. New York: Arno Press Inc., 1976.

Lessard, Michel and Huguette Marquis. COMPLETE GUIDE TO FRENCH-CANADIAN ANTIQUES. New York: Hart Publishing Company, Inc., 1974.

Life, Editors of. AMERICA'S ARTS AND SKILLS. New York: E. P. Dutton & Co., Inc., 1957.

Lindsay, J. Seymour. IRON AND BRASS IMPLEMENTS OF THE ENGLISH HOUSE. London: Alec Tiranti, 1927.

Maust, Don A., ed. AMERICAN WOODENWARE AND OTHER PRIMITIVES. Uniontown, Pennsylvania: E. G. Warman Publishing, Inc., 1974.

McClintock, Inez and Marshall. TOYS IN AMERICA. Washington, D.C.: Public Affairs Press, 1961.

McClinton, Katharine Morrison. COLLECTING AMERICAN VICTORIAN ANTIQUES. New York: Charles Scribner's Sons, 1966.

Mercer, Henry C. ANCIENT CARPENTERS' TOOLS. Doylestown, Pennsylvania: The Bucks County Historical Society, 1975.

Minhinnick, Jeanne. AT HOME IN UPPER CANADA. Toronto: Clarke, Irwin & Company Limited, 1970.

Mirken, Alan, ed. 1927 EDITION OF THE SEARS, ROEBUCK CATALOGUE. New York: Bounty Books, a Division of Crown Publishers, Inc., 1970.

Mountfield, David. THE ANTIQUE COLLECTOR'S ILLUSTRATED DICTIONARY. London: The Hamlyn Publishing Group Limited, 1974.

Nutting, Wallace. FURNITURE TREASURY, VOLUMES I AND II. New York: The Macmillan Company, 1928.

Partridge, Michael. FARM TOOLS THROUGH THE AGES. Boston, Massachusetts: Promontory Press, 1973.

Pinto, Edward H. TREEN AND OTHER WOODEN BYGONES. London: G. Bell & Sons, 1969.

Poulet, Lance. "WOOSDMAN'S FOLK ART, SPRUCE GUM BOXES", Waldoboro, Maine: MAINE ANTIQUES DIGEST. Vol. 4 No. 9 October, 1976, 18C-19C.

Revi, Albert Christian. NINETEENTH CENTURY GLASS, ITS GENESIS AND DEVELOPMENT. REVISED EDITION. New York: Thomas Nelson Inc., 1967.

_____, ed. SPINNING WHEEL'S COLLECTIBLE IRON, TIN, COPPER & BRASS. Secaucus, N.J.: Castle Books, 1974.

_____, ed. THE SPINNING WHEEL'S COMPLETE BOOK OF ANTIQUES. New York: Grosset & Dunlap, 1972.

Rhodes, Lynette I. AMERICAN FOLK ART FROM THE TRADITIONAL TO THE NAIVE. Cleveland, Ohio: The Cleveland Museum of Art, 1978.

Roberts, Kenneth D. Documentary by. TOOLS FOR THE TRADES AND CRAFTS, AN EIGHTEENTH CENTURY PATTERN BOOK, R. TIMMINS & SONS, BIRMINGHAM. Fitzwilliam, N.H.: Ken Roberts Publishing Co., 1976.

Root, A. I. THE ABC OF BEE CULTURE. Medina, Ohio: The A. I. Root Company, 1877. Revised and almost entirely re-written by E. R. Root, 1905.

The Rushlight Club, comp. EARLY LIGHTING, A PICTORIAL GUIDE: Boston: The Rushlight Club, 1972.

Russell, Loris S. A HERITAGE OF LIGHT, LAMPS AND LIGHTING IN THE EARLY CANADIAN HOME. Toronto: University of Toronto Press, 1968.

Salaman, R. A. DICTIONARY OF TOOLS USED IN THE WOODWORKING AND ALLIED TRADES C. 1700-1970. New York: Charles Scribner's Sons, 1975.

Schroeder, Joseph J. Jr., ed. MONTGOMERY WARD & CO. 1894-95 CATALOGUE & BUYERS GUIDE No. 56. Northfield, Illinois: The Gun Digest Company, 1970.

_____, ed. SEARS, ROEBUCK & CO. CONSUMERS GUIDE FALL 1900. CATALOGUE No. 110. Northfield, Illinois: Digest Books, Inc., 1970.

_____, ed. 1896 ILLUSTRATED CATALOGUE OF JEWELRY & EUROPEAN FASHIONS, MARSHALL FIELD & CO. Chicago: Follett Publishing Company, 1970.

Shea, John G. THE AMERICAN SHAKERS AND THEIR FURNITURE WITH MEASURED DRAWINGS OF MUSEUM CLASSICS. New York: Van Nostrand Reinhold Company, 1971.

Sloane, Eric. ABC BOOK OF EARLY AMERICANA. New York: Doubleday & Company, Inc., 1963.

_____. AMERICAN YESTERDAY. New York: Funk & Wagnalls, 1956.

_____. A MUSEUM OF EARLY AMERICAN TOOLS. New York: Funk and Wagnalls, 1964.

_____. REVERENCE FOR WOOD. New York: Funk & Wagnalls, 1965.

Smith, Elmer L. EARLY IRON WARE. Lebanon, Pennsylvania: Applied Arts Publishers, 1974.

_____. EARLY TOOLS AND EQUIPMENT. Lebanon, Pennsylvania: Applied Arts Publishers, 1974.

_____. TINWARE, YESTERDAY AND TODAY. Lebanon, Pennsylvania: Applied Arts Publishers, 1970.

_____, comp. AMERICAN WILDFOWL DECOYS FROM FOLK ART TO FACTORY, A SAMPLER OF THE COLLECTIBLES. Lebanon, Pennsylvania: Applied Arts Publishers, 1974.

Smith, H. R. Bradley. BLACKSMITHS' AND FARRIERS' TOOLS AT SHELBURNE MUSEUM, MUSEUM PAMPHLET SERIES, NUMBER 3. Shelburne, Vermont: The Shelburne Museum Inc., 1966.

Smith, Jean & Elizabeth. COLLECTING CANADA'S PAST. Toronto: Prentice-Hall of Canada, Ltd., 1974.

Sprigg, June. BY SHAKER HANDS. New York: Alfred A. Knopf, 1975.

Stein, Kurt. CANES & WALKING STICKS. York, Pennsylvania: Liberty Cap Books, 1974.

Stevens, Gerald. IN A CANADIAN ATTIC. Toronto: McGraw-Hill Ryerson Limited, 1963.

Stoddart, Jack, ed. THE 1901 EDITIONS OF THE T. EATON CO. LIMITED CATALOGUES FOR SPRING & SUMMER, FALL & WINTER. Toronto: The Musson Book Company, 1970.

Thwing, Leroy. FLICKERING FLAMES, A HISTORY OF DOMESTIC LIGHTING THROUGH THE AGES. Rutland, Vermont: Charles E. Tuttle Co., Inc., 1958.

Watson, Aldren A. THE VILLAGE BLACKSMITH. New York: Thomas Y. Crowell Company, 1968.

Webster, David S. and William Kehoe. DECOYS AT SHELBURNE MUSEUM, MUSEUM PAMPHLET SERIES, NUMBER 6. Shelburne, Vermont: The Shelburne Museum Inc., 1961. Revised edition 1971.

Webster, Donald Blake. EARLY CANADIAN POTTERY. Greenwich, Connecticut: New York Graphic Society Limited, 1971.

_____. EARLY SLIP-DECORATED POTTERY IN CANADA. Toronto: Charles J. Musson Limited, 1969.

_____, ed. THE BOOK OF CANADIAN ANTIQUES. New York: McGraw-Hill Co., 1974.

Wildung, Frank H. WOODWORKING TOOLS AT SHELBURNE MUSEUM, MUSEUM PAMPHLET SERIES, NUMBER 3. Shelburne, Vermont: The Shelburne Museum Inc., 1957.

Wills, Geoffrey. ANTIQUE GLASS FOR PLEASURE AND INVESTMENT. New York: Drake Publishers Inc., 1972.

Wilson, Kenneth M. NEW ENGLAND GLASS AND GLASSMAKING. New York: Thomas Y. Crowell Company, 1972.

Worcester, Joseph E. A DICTIONARY OF THE ENGLISH LANGUAGE. London: Sampson, Low, Marston, Low and Searle, 1859.

Wright, Philip. OLD FARM IMPLEMENTS. London: A and C Black, Ltd., 1961.

YANKEE'S BOOK OF WHATSITS. Dublin, N.H.: Yankee, Inc., 1975.

Index